HOW CAN I BE NOBODY

EDITED BY
SYLVESTER OKWUNODU OGBECHIE

WITH CONTRIBUTIONS BY
AYANNA DOZIER
AKIL KUMARASAMY
MOYO OKEDIJI
RACHEL VERA STEINBERG

VICTORIA-IDONGESIT
UDONDIAN

HIRMER

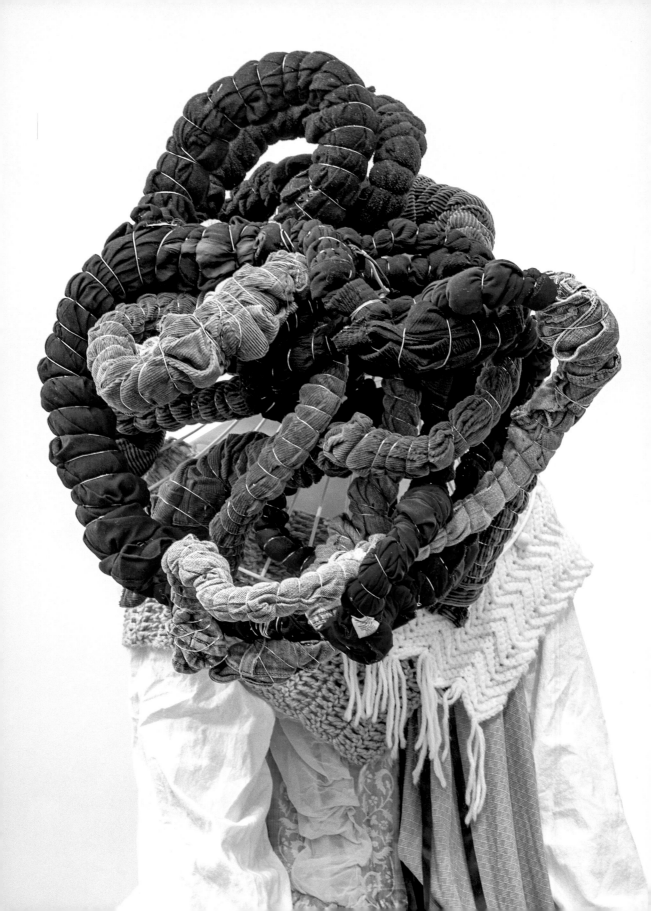

Rachel Vera Steinberg

FOREWORD

Upon entering Smack Mellon's gallery space in the spring of 2022 to see Victoria-Idongesit Udondian's solo exhibition *How Can I Be Nobody*, the first thing one noticed was the sheer amount of material in the space. Thousands of discarded black garments, woven and stitched together, covered the twenty-four by fifty-seven-foot main gallery wall and three eighteen-foot-high columns, and created two draping canopies through which visitors could pass. Two sculptures resembling ship ribs made of steel and wood hovered over the floor, hemorrhaging white shirts and black casts of human hands and discarded shoes, respectively. Suit jackets rose like ghosts from the ground, as if crawling in unison toward the gallery's entrance.

The exhibition, Udondian's first major solo presentation in New York City, continued the artist's ongoing work exploring the links between bodies and transit within global labor economies and the foundational role of immigrant labor in capitalist production. Smack Mellon's Dumbo gallery, a former industrial site itself, served as a potent container for the installation. The defunct concrete coal trough that structures the gallery's unique ceiling architecture was appropriately haunted by the garments that were conspicuously empty of bodies and woven together into impossibly heavy tapestries. The heaps and expanse of discarded clothing and shoes offered a terrain that was far more than the sum of its parts: ignorable as single objects, but imposing en masse. As one of the largest sole contributors to global waste, the disused textiles signaled both to cultures of disposability spurred by capitalism's operative as an accelerant, as well as the bodies of the often cast-aside individuals whose labor drives production.

Udondian herself was trained previously as a tailor and fashion designer. She began this project in 2019 with a call for collaborators from immigrant communities. The most notable for this exhibition was a partnership with Stitch Buffalo, a textile center near the artist's studio that facilitates refugee and immigrant women in creating handcrafted goods to encourage economic empowerment. She compensated these individuals to assist in creating the monumental weavings on display, and worked with them to record their stories and make casts of their hands. Their voices and labor were the backbone of this work, both literally and metaphorically.

The recordings and casts contributed to the sculptures *Ubom Keed* (2021, metal, life-cast hands, used clothes, sound) and *Ubom Iba* (2021, metal, salvaged shipping pallets, used shoes, shoelaces, sound)—the aforementioned ship ribs. The structures were designed to reference the *Brooks* slave ship as well as the numerous migrant boats lost on the Mediterranean Sea, while the shoes, clothes, and hands stand in for migrant bodies. The shipping palettes

that create the skeleton of *Ubom Iba* connect the migration of goods to the often unseen labor by immigrant workers in support of the global economy. The visceral combination of materials and the actual voices of Udondian's collaborators challenged assumptions that delineate who or what is visible, and what or who is disposable.

The exhibition's title came to the artist later in planning the exhibition while she reviewed the stories she had recorded. The quote "How can I be nobody and tell you my story?" was spoken by one of Udondian's collaborators who struggled to divulge her personal history for fear that it would put the community in her home country in danger. The chilling sentiment conveys the anxieties of persecution that many immigrants and refugees carry with them into unfamiliar places due to lack of protection and resources.

The texts and images in this book will further divulge the power, histories, and significance behind this work, which from inception to completion was no small feat. In the face of festering intolerance and nationalism across many Western countries, this work reminds us of the invaluable contributions of immigrant populations. Over a year after the exhibition's completion at Smack Mellon, this catalogue remains a witness to Udondian's project of re-empowerment as the artist continues her work of facilitating individuals from marginalized social groups to use their stories to create collective understandings of their shared historical pasts.

How Can I Be Nobody installation shot

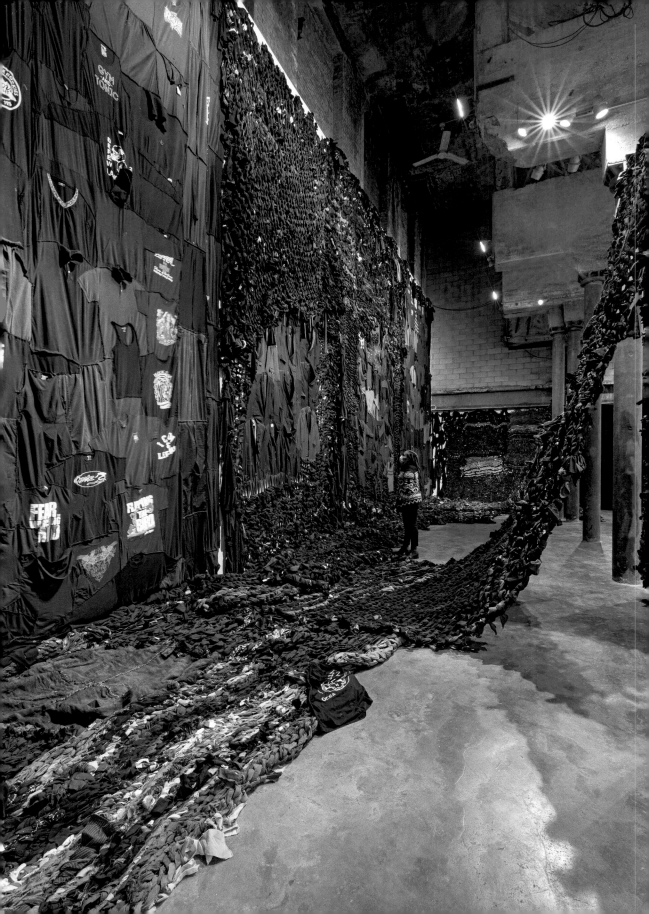

SYLVESTER OKWUNODU OGBECHIE

VICTORIA-IDONGESIT UDONDIAN: OF BODIES AND NOBODIES IN GLOBAL SPACE

In March 2022, contemporary artist Victoria-Idongesit Udondian presented a site-specific solo exhibition at the Smack Mellon in New York City, featuring artworks that combined elements from recent collaborative projects including woven textiles, sculptures, sound, and performance art.[1] (Fig. 1) The exhibition took its title from the Efik phrase *Nsi nam mi ken di owo* (*How Can I Be Nobody*),[2] which reflects Udondian's ongoing interest in the foundational role of migrant labor in capitalist production. The tone of artworks in this exhibition was dark: a huge installation anchored by a wall consisting of various forms of cloth accompanied by piles of shoes and severed hands cast in plaster, clustered in two boat-shaped forms. The boats are mere frameworks without the finishings of boards and caulk that would make them seaworthy. One boat is wooden, while the other is made from welded steel. The wall of textiles is one continuous mass but can be seen as a triptych. Two side panels of black, blue, and brown T-shirts stitched together frame a center panel featuring an imposing tapestry braided out of bunched strips of cloth whose mass flows out from the wall onto the ground and continues as a wall hanging draped over a line strung between two pillars. Udondian makes creative use of the architectural limitations of the exhibition space by converting its six load-bearing iron pillars into an integral part of her installation. (Figs. 2, 3) She uses two of the three pillars in front of her tapestry as support for the wall hanging and wraps the three opposite pillars in cones of stitched clothing whose flow suggests Yoruba Egungun

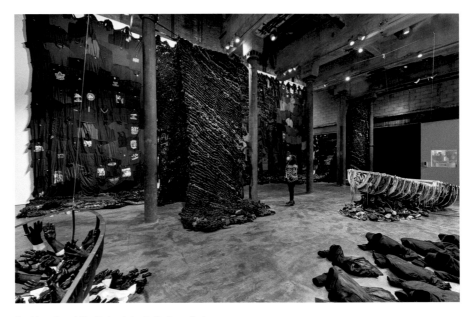

1 *How Can I Be Nobody* installation shot

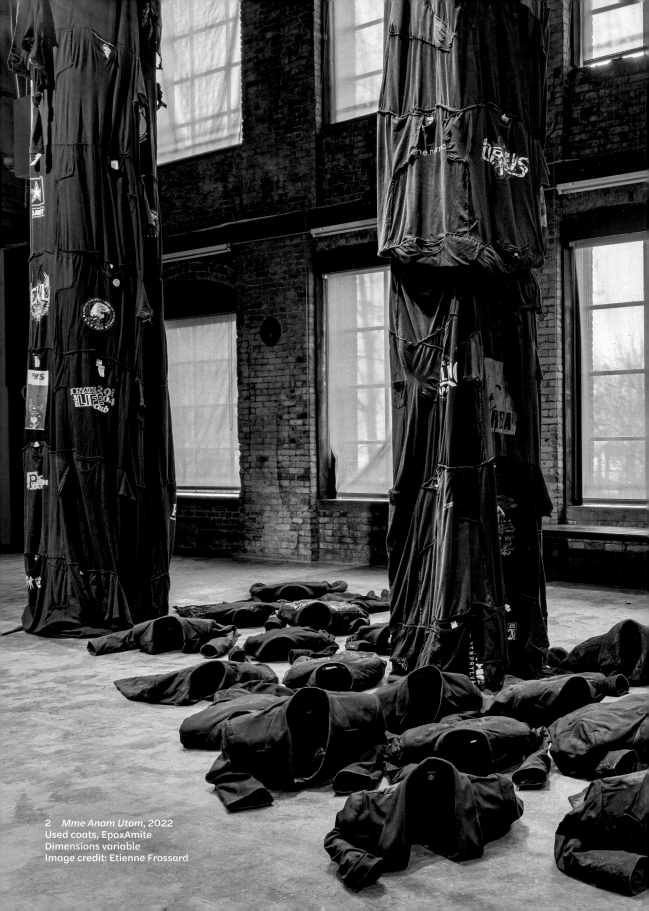

2 *Mme Anam Utom*, 2022
Used coats, EpoxAmite
Dimensions variable
Image credit: Etienne Frossard

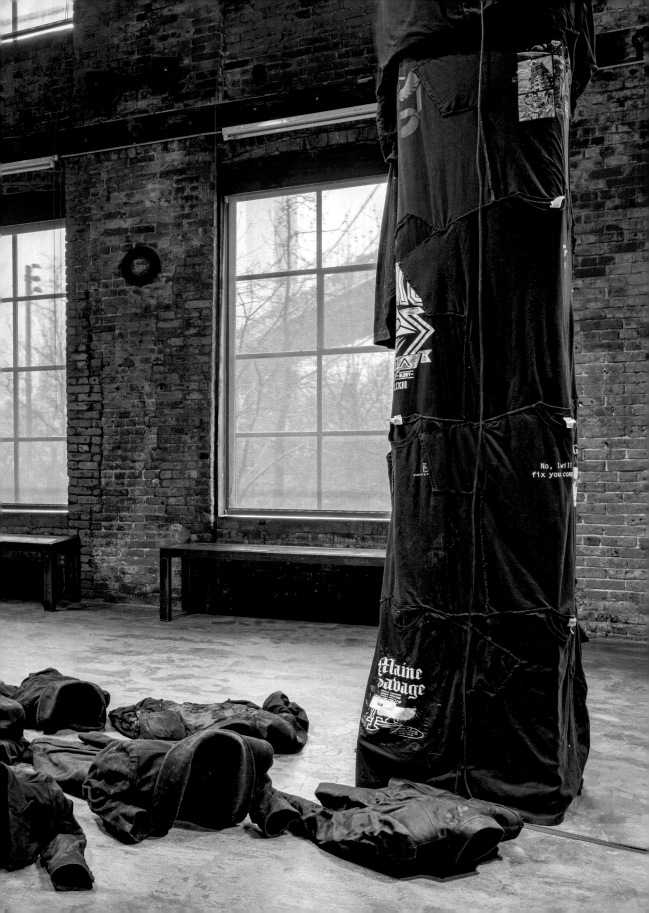

masquerades. Identifiable logos of the US Army and the comic book character Superman (among others) dot the flowing fabric. A group of empty shirts crawl past the bottom of these three pillars. Starched and molded into carapaces of human bodies, these shirts are the most disturbing element in the overall installation. They are literally no-body, their corporeal forms effaced by the vicissitudes of their plight. The horde of ghostly empty shirts are frightful in their desperation and determination. (Fig. 4)

How Can I Be Nobody's installation is immersive and dense with a plethora of objects; an unruly profusion that speaks to the difficulty of global migrancy and forced flight. This is reflected in the vast number of clustered empty shoes serving as a base for the wooden boat and the casts of hands clustered into the boat with an iron frame. The cast hands reside in and around the suspended ship rib, constructed to reference the eighteenth-century diagram of the infamous slave ship *Brooks*[3] and the countless rickety boats that carry desperate African migrants who drown in the Mediterranean Sea in vast numbers.[4] These limbless hands, many painted black and some painted in identifiable national colors (those of the flags of Ghana and Brazil are easily noticeable) suggest enduring trauma. They reference drowning bodies in the way they reach skyward as if hoping for someone to pull them out of turbulent waters. In fact, slave ships were notorious for throwing dead or sick African captives overboard.[5] There are also the haunting shapes of empty clothes crawling across the floor,

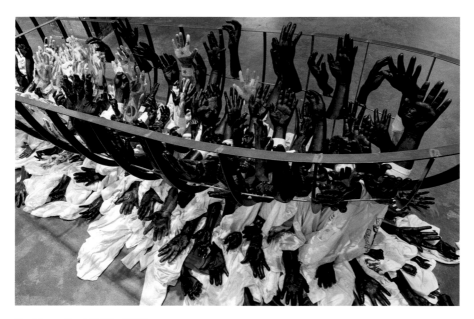

3 *Ubom Keed*, 2020–2022
Metal, life-cast hands, used clothes, various country flags
Dimensions variable
Image credit: Etienne Frossard

4 *Ofong Ufok*, 2019–2022, Gallery-wide installation
Second-hand clothes, repurposed textile, rope, dye, large woven textiles
Dimensions variable
Image credit: Etienne Frossard

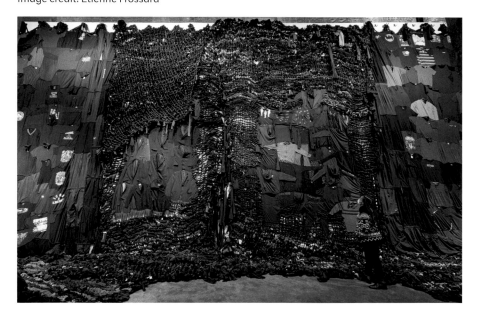

and above all these dense articles of clothing; so much cloth. The vast agglomeration of the installation occupies material space and causes a sense of spatial disorientation at the same time. Udondian's *How Can I Be Nobody* is thus a multivocal multimedia installation dense with meaning, the kind of work that interrogates history and material culture to reveal humanity in the handmade.[6] It is a feminist interrogation of commodity fetishism in global capital.

OF BODIES AND NOBODIES IN GLOBAL SPACE

How Can I Be Nobody is a good place to begin our examination of Victoria-Idongesit Udondian's art, given how it highlights the precarity of human identity in contexts of migration. As an artist from Nigeria who has worked globally, Udondian has experienced migration and immigration processes as a fundamental part of her life and career. Her very existence as a black global artist invokes the hegemonic governmentality that frames the process of securing legitimate passage through, and residence in, Western countries.[7] Udondian was born in Nigeria in 1982 and trained as a tailor and fashion designer before studying at the University of Uyo, graduating with a BA in painting in 2004. After a decade of international practice that included attending the Skowhegan School of Painting and Sculpture, she enrolled for

and received an MFA in sculpture and new genres at Columbia University in New York City. She is currently a visiting associate professor of art at the State University of New York at Buffalo. Udondian was named a Guggenheim Fellow in 2020 for a project proposal that developed into her Smack Mellon exhibition.

Victoria-Idongesit Udondian describes herself as a contemporary artist whose work is driven by an interest in textiles and the potential for clothing to shape identity, informed by the histories and tacit meanings embedded in everyday materials. She uses these to create interdisciplinary projects that question notions of cultural identity and postcolonial positions in relation to her experiences growing up in Nigeria.[8] Textiles and cloth of all kinds have a complex and complicated history in Africa, having at various times served secular and sacred functions as well as being a key item of regional and international trade well before Portuguese sailors began to explore the West African coast in the fifteenth century.[9] Udondian's artworks reference contemporary aspects of this complex history by examining the impact of second-hand clothing in the Nigerian and African context, and especially in how used clothing travels from the Western world to the global South as a significant trade commodity. She is especially interested in the intersectionality of the global trade system and the movement of goods and people from one part of the world to the other, which intersects with the politics of migration and governmentality.

Udondian sees art as a tool that helps her make sense of the world, and she uses the art-making process to explore the complexities of migration, immigration, and racial and cultural identity in the global context. Drawing from her experiences growing up in Nigeria, she repurposes West African textiles exhibited in Nigerian and Western contexts to investigate how fundamental changes in fabric can affect one's perception of one's identity. Most of her recent work is premised on the idea that identities are constantly shifting in the process of migration. This premise illustrates the liminal nature of migrants: a first-generation immigrant is a stranger in the adopted land and also in the land left behind. As Willem Schinkel noted, "a migrant is someone coded as a person who might not have been here. What is this coding? It is to imagine, and make a record of, what the nation would be if the people marked as migrants—those who might have not been here—did not exist."[10] The fate of the undocumented migrant is even more precarious: they are often placed beyond the pale of humanity and described as pests or, at best, problems against which the citizens of well-off states must be protected. African migrants are especially demonized in this process.[11] They are often intercepted at sea and sent to camps in eastern Europe, where they face horrific conditions of internment that

Italian philosopher Giorgio Agamben once described as "bare life."[12] Given Udondian's extensive research on the role of Italy in the West African second-hand clothing trade, it is truly ironic that Italy is the most egregious offender in this regard, being favored as a first stop for many African migrants crossing the Mediterranean into Europe from North Africa.

Agamben defines bare life as human life included in the juridical order solely in the form of its exclusion, that is, of its capacity to be ended. The power of hegemonic law to actively separate "political" beings (citizens) from "bare life" (bodies) is evident in the ease with which the myriad Africans who drown in the Mediterranean are dismissed from reckoning. Defined as "hordes" rather than as fellow human beings acting out of judicious need, they are condemned to nothingness in death as elements that are outside the bounds of the political community. To paraphrase Agamben, the camps that these migrants are consigned to is a space in which its inhabitants are stripped of every political power and wholly reduced to bare life. It is an absolute biopolitical space of exception that must be understood as an ever-present condition of migrant life in the contemporary global order.[13] The biopolitical nature of sovereign exception that reduces African migrants to bare life challenges globalization's facile notion of a free transmission of ideas, contexts, and artists since it serves to fix Africans in their place rather than allow them free global mobility.

Earlier on, the discourse of globalization argued for the need to make the international art world more accessible to people everywhere rather than dwelling on discourses of racialized identities. However, this noble goal confronts the rather obvious conundrum that racialized identities, especially those of black people, tend to equate with lack of economic, political, and even geographical freedom in the global context. The mobility taken for granted in the discourse of globalization seems to apply only to those who hold the appropriate Western passports, markers of occidental heritage that enable anxiety-free transit. The rest are locked into second-class status in the global world order. In this regard, the well-policed borders of the Western world serve as a means of inscribing the locality of non-Western (especially African) subjects.

The idea of globalization is itself under question in the wake of the global pandemic. COVID-19 broke the world and left the lofty rhetoric of globalization tripped up by the harsh reality that all spaces are local. In the wake of the pandemic, a cold wind of intolerance and nationalism is blowing across America and Europe as immigrants are vilified and nationalistic biases increasingly divide nations. Udondian's contemporary art interrogates how the arbitrariness of power structures inherent in immigration policies create divergent migrant experiences. She pushes back against the notion of bare life by asserting the

foundational role of migrant labor in capitalist production, and her artworks often engage with immigrant communities to showcase and highlight their contributions to building the country (the US in this regard), both past and present. This is reflected in the limbless hands in *How Can I Be Nobody*—the hands of immigrants who have contributed so much to the building of the country. It also alludes to the effaced bodies that die in the course of voluntary or forced migration.

Udondian collects immigrant stories that, along with her sculptures, become artifacts for her art. She has developed relationships with various migrant communities to enable partnerships through which she has collaborated with and compensated community members, weaving with them and creating sculptural casts of their hands for use in her installations. Collaborators were asked to donate their used work clothes, preferably in black, in exchange for new ones. These collected items of clothing were then frozen into forms that reference the bodies of their owners, from which Udondian constructs hollow crawling figures. Installed on the floor, the hollow forms allude to the repressive, exploitative conditions faced by migrant workers within neocolonial systems of labor. In fact, the large-scale collaborative weavings included in *How Can I Be Nobody* are primarily composed of repurposed dark-colored fabrics in acknowledgment of the black and brown lives lost in search of better living conditions. "By bridging direct engagement with these communities and contemporary art audiences, Udondian facilitates individuals from marginalized subcultural groups in constructing a shared understanding of their historical past to promote re-empowerment."[14]

STARTING OUT: ENGAGING GLOBAL CONTEMPORARY ART IN NIGERIA

Victoria-Idongesit Udondian emerged on the art scene at a time of great transformation in global contemporary art. The late Nigerian-American curator Okwui Enwezor (1963–2019) had placed contemporary African art firmly on the global stage with two major exhibitions, *The Short Century* (2001) and *documenta11* (2002). African artists such as Yinka Shonibare and El Anatsui (among many others) were redefining the formal and conceptual orientation of contemporary art: Shonibare by exploring Dutch wax textiles (the iconic Dutch-made Vlisco fabrics popularly known as "African cloth"), and Anatsui through his metal and copper-wire installations that reinterpreted the architectonics of Kente and other Akan strip-woven textiles. The global art world took notice,

5 *Okrika Bale*, 2011
Used clothes, repurposed shipping rope
Dimensions variable
Image credit: Roberto Moro

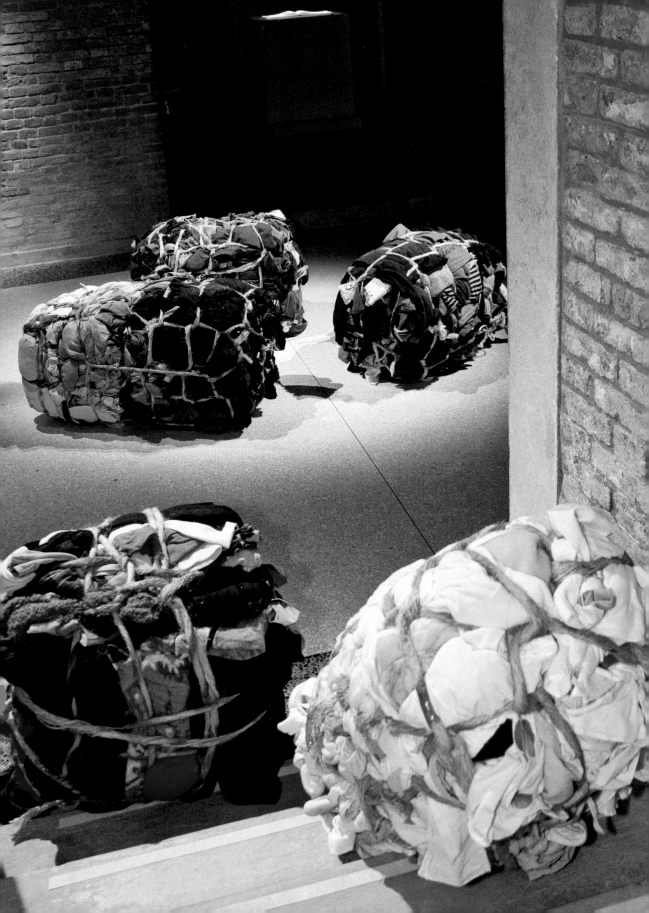

and interest in African contemporary artists grew exponentially. Major debates about forms and protocols of art-making were taking place in Nigeria as younger artists moved away from modernist painting protocols to photography, video, performance, and new media art. However, the art ecosystem needed to promote these new developments was lacking in most parts of Africa.

Udondian emerged from art school into this vibrant context of contemporary art discourse. Her professional practice, which initially combined painting and textiles to produce mixed-media canvases replete with floral fiberwork forms, benefited from her earlier training as a tailor and fashion designer. Hobbled by the constraint of sourcing expensive foreign-made oil paints for her artworks, Udondian found inspiration in the works of contemporary artist El Anatsui, a native of Ghana who has lived in Nigeria since 1975 and a stalwart figure of the Nsukka School.[15] Anatsui uses recycled materials to create complex artworks, and his influence on contemporary African art is inestimable. According to Udondian, "Anatsui reshaped my awareness of art materials … showing us how we could rethink art, rethink materiality, rethink access, and even rethink the meaning of 'painting' and 'sculpture.'"[16] Udondian noted how Anatsui's practice shifted from working with engraved wood panels to creating large-scale sculpture installations using bottle caps sourced from Nigerian breweries and stitched together with copper wire into large panels, which became a signature style that propelled him to the forefront of global contemporary art.

Anatsui's experimental art opened Udondian's eyes to a world of possibility and inspired her to work with textiles and second-hand clothing. She developed into an interdisciplinary artist who works across genres with a huge interest in global trade systems focusing on textiles, repurposing second-hand clothing to create hybrid regalia activated through performances and photography. This orientation is already visible in Udondian's *Habitus Project: Okrika Bale* (2011), for which she studied the process of collecting and exporting used clothing from Italy to the African continent. (Fig. 5) These kinds of used clothes are known in eastern Nigeria as *okrika*, an Igbo word that loosely translates as "tattered." According to the artist, *Okrika Bale* was produced during a residency in Venice. It resulted from a survey she conducted in collaboration with the Associazione San Vincenzo Ca' Letizia in Italy, the Mestre chapter of the St. Vincent de Paul Society Charities, an international lay Catholic organization dedicated to assisting those in need. Udondian integrated some of these used clothes into sculptures that deliberately take the shape of bundled pallets of *okrika*, the typical form in which packaged used clothing arrives for sale on the Nigerian market.

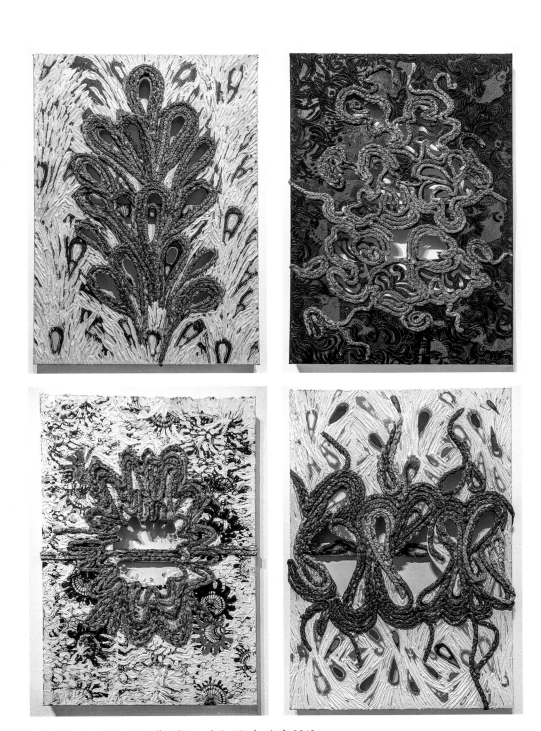

6 *Mum's Bottom Box Hollandis; Made in USA* (series), 2016
Mixed media on canvas
36 × 24 in. each
Image credit: Courtesy of the artist

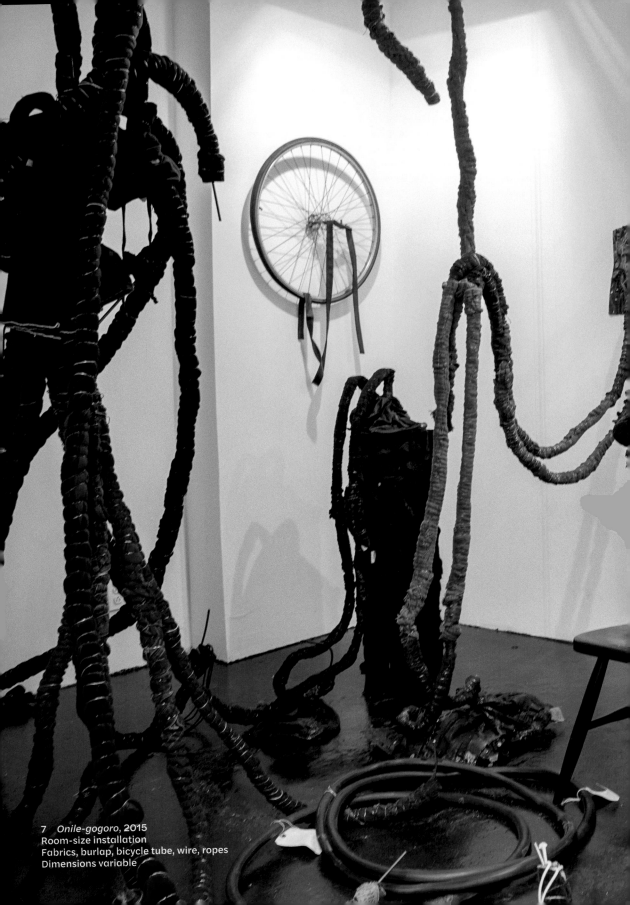

7 *Onile-gogoro*, 2015
Room-size installation
Fabrics, burlap, bicycle tube, wire, ropes
Dimensions variable

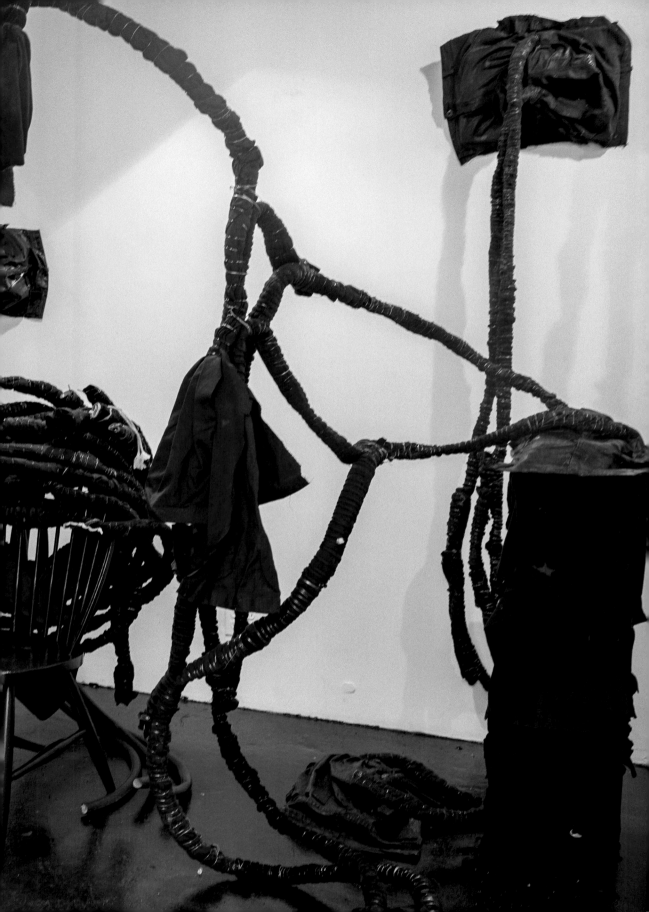

Okrika Bale consists of five pallets of clothing bound in ropes made from strips of the same cloth. Strategically placed within the exhibition space, the sculptures show the paradox of how a shipment that begins in Italy as an act of charity is transformed in transit through the dynamics of an uncontrollable monetary exchange. This process of transformation reflects the unholy union of North-to-South humanitarianism and global capitalism, which wraps the banal reality of using Africa as a dumping ground for Western waste in the chaste attire of humanitarian aid. Udondian notes that since the early 1980s, the used clothes market has significantly contributed to the decline and the subsequent deep crisis of the local textile industry in Nigeria and other African economies.[17]

Udondian's artworks unfold in series, allowing us to track a specific line of development from the early fiber canvases of *Mum's Bottom Box Hollandis* (*sic*) (2014–2019) to her current series, *The Republic of Unknown Territory* (2019 to date).[18] The former series riffs on Yinka Shonibare's creative deconstruction of "Dutch Wax" textiles into a visual form that has since become a signature style for the artist. Produced by the Vlisco company (Netherlands), "Dutch Wax Hollandais" fabrics are otherwise commonly known as African cloth, having become a key sartorial element in global African fashion.[19] Vlisco fabrics developed from a Dutch effort to copy Indonesian batik textiles. They were introduced to Ghana and West Africa by returning Ghanaian troops who had served in the Royal Netherlands East Indies Army between 1855 and 1872, and were subsequently adapted to suit local tastes.[20] This cloth is infinitely malleable, loaded with cultural symbolism, and is an important marker of capitalist processes. Shonibare uses these particular textiles to interrogate contemporary cultural identity and the hidden histories of transnational engagements woven into the fabrics. "In Shonibare's work, the fabrics do conceptual double duty: they act as a symbol of 'African culture,' for those who perceive their patterns to be indigenous, and as a symbol of our hyperconnected, postcolonial material world."[21]

In the series *Mum's Bottom Box Hollandis,* Udondian wove the bright colors of Dutch Wax textiles into thick braids that she used to create tactile three-dimensional surfaces. (Fig. 6) The sinuous form of the braids recalls African hairstyle designs, a mainstay practice of black women's hair styling that's increasingly becoming unisex. Her fascination with braids and braided hair continues through her work and becomes an overriding concern in the series *Onile-gogoro* (2014–2015), which she based on Nigerian photographer J. D. 'Okhai Ojeikere's photographs (made between 1968 and 1975) of a particular Yoruba women's hairstyle. (Fig. 7) *Onile-gogoro* (literally, "owner of

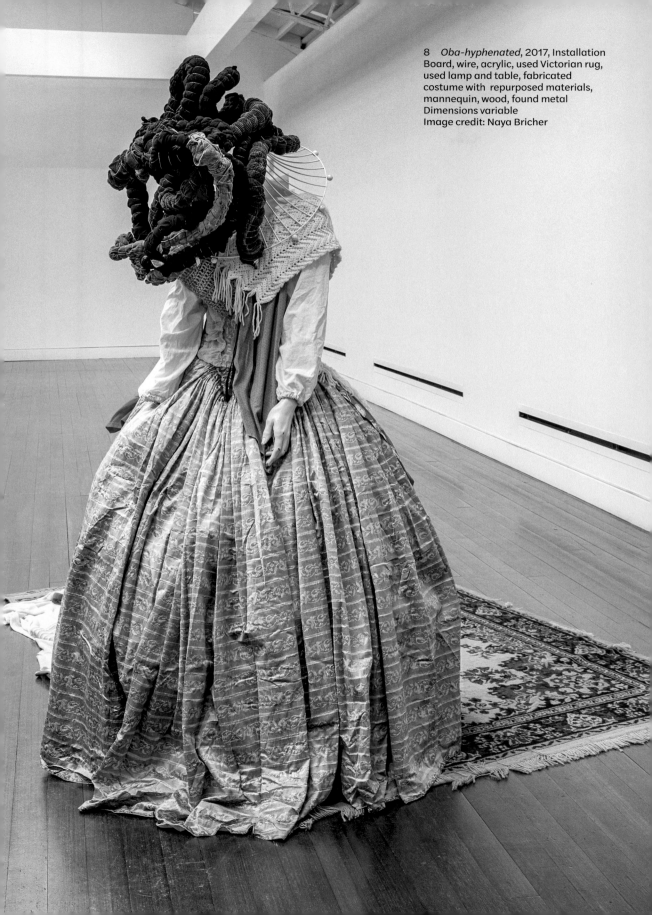

8 *Oba-hyphenated*, 2017, Installation
Board, wire, acrylic, used Victorian rug,
used lamp and table, fabricated
costume with repurposed materials,
mannequin, wood, found metal
Dimensions variable
Image credit: Naya Bricher

9 *Oba-hyphenated*, 2017, Installation
Fabricated costume with repurposed materials, second-hand textiles, board,
wire, acrylic, used lamp and table, mannequin, wood, screen print
Dimensions variable

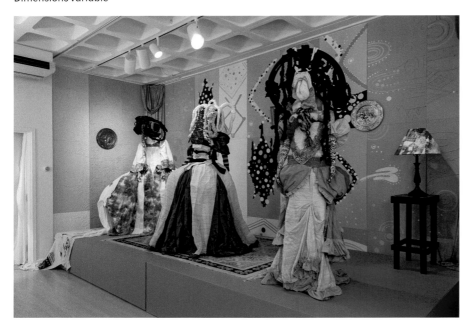

a tall building"), a Yoruba word loosely translated as "skyscraper," is notable
among the unique terms associated with postcolonial Nigeria. "In architec-
ture, the term was invoked colloquially in the 1960s to signify the emergence of
multi-level public and private building projects throughout the country, espe-
cially in the southwestern regions of Nigeria."[22] For most Nigerians, however,
the *Onile-gogoro* hairstyle is forever linked to the construction of Cocoa House,
Nigeria's first skyscraper, in Ibadan. Standing twenty-five stories tall and
located in the heart of the city adjacent to Dugbe, Ibadan's central market, the
building was completed in 1965 and was at that time the first skyscraper in
West Africa. Cocoa House served as a symbol of the changing fortunes of
Nigeria, an architectural summation of a shift from a prosperous agriculture-
based economy to its contemporary reliance on petroleum exports.

In her treatment of the *Onile-gogoro* theme, Udondian shifts her focus
from the elegance of Yoruba hairstyles to the unruly aesthetics of matted hair in
a composition constructed from braided ropes of fabric that recall Jamaican
Rastafarian dreadlocks, made popular by reggae artists such as Bob Marley.
The thick braided cords in Udondian's *Onile-ogoro* composition slither across
the exhibition space and are piled high on a chair in the center of the instal-
lation, coiled in a conical form similar to how Rastafarians wear their hair. Made
entirely of repurposed materials, the braided cords in the composition occupy

architectural and sculptural space while hinting at the devotion and care needed to sustain dreadlocks, which Rastas wear as a form of spiritual devotion.

References to big hair are also evident in *Oba-hyphenated* (2017), an installation that references the sacrality of the king's body in African culture. (Figs. 8, 9) The king's dress, fabricated from used clothing, references the late nineteenth-century royal court regalia of the European nations that colonized Africa. Udondian replaced their heads with constructed African-inspired head-dresses, thus creating a hybrid of nineteenth-century Western and African royal regalia. More importantly, Udondian inverts the assumption that Obas are usually male by invoking the multi-gendered nature of African kings, which Suzanne Blier described as a striking element of cross-gender identity that sacralizes the king's body as sorcerous and transsexual.[23] The Obas in Udondian's installation are dressed in Victorian-style female garb, and some display nude female torsos. However, all of them are gender-fluid by virtue of their covered faces and the riotous ropes of braided hair piled on top of their heads. In most African cultures, the king's body is imbued with sacred authority and spirituality. These are echoed in the mordant form of the seated king in the main installation of *Oba-hyphenated* despite the fact that its quotidian regalia is stitched together from the used clothing central to Udondian's practice. This deference to spirituality, a search for deeper states of meaning in everyday objects, is an important element of Udondian's practice as a contemporary artist.

NDISE MMI: SELF-PORTRAITURE AS PERFORMANCE AND RITUAL

In the artworks discussed above, Udondian interrogates cultural identity as a process of transformation rather than as a fixed condition of being. Nowhere in her work is this more evident than in the *Arti-tude* series (2013). According to the artist, "The *Arti-tude* project exposes the dynamics and complexities of Nigerian fashion as an identity across generations and cultures, as researched in archival documents and photos from key historical eras, and derived from Nigerian sartorial identities influenced by European and other foreign contacts with Africa."[24] Articulated in a series of nine self-portraits collectively titled *Ndise Mmi (self-portrait)*, which show the artist in various Nigerian ethnic garb, Udondian uses her body to interrogate ethnic identities across the Nigerian fashion landscape. (Figs. 10, 11) The items she wore in the performance and photographs were all made from scraps of second-hand clothes combined with

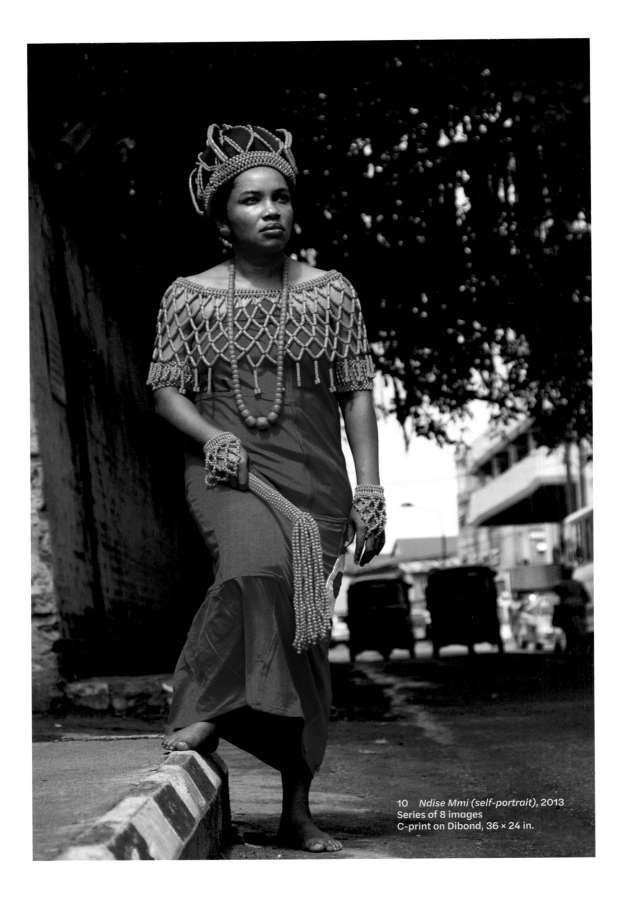

10 *Ndise Mmi (self-portrait)*, 2013
Series of 8 images
C-print on Dibond, 36 × 24 in.

11 *Ndise Mmi (Yoruba Chief)*, 2013
Series of 8 images
C-print on Dibond, 24 x 36 in.

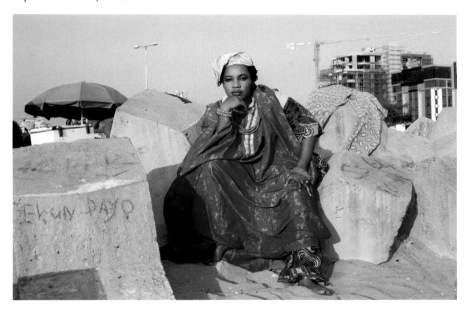

imported textiles used in different parts of Nigeria as markers of traditional/ ethnic identity. In one self-portrait, she is dressed as a Yoruba chief in a gorgeous red and blue attire posed against a high-rise construction site at the famous Bar Beach of the Atlantic coast in Lagos (the concrete tetrapod seawall bulwarks of the beach are unmistakable). In another, she is dressed in the regalia of an Edo-Benin queen complete with coral-beaded headdress, collar, gloves, and fly whisk. Her long dress in this image has the same look as the textile-adorned iron posts in *How Can I Be Nobody*. Udondian wears a Yoruba-style young man's dress in yet another self-portrait and stands in deep shadow. Other photographs show her dressed as an Igbo matron, a Yoruba lady, a Fulani milkmaid, and striking a pose as a classical "Sisi Eko" (modern Lagos woman), decked out in the style of 1960s post-independence-Nigeria fashion. Patterned in bright red, purple, green, orange, and blue colors with a matching red head-dress, the Sisi Eko outfit challenges ideals of indigenous Yoruba fashion that espouse what Robert Farris Thompson famously described as "an aesthetics of the cool."[25]

 Udondian's self-portrait as an Ibibio maiden is perhaps the most import-ant artwork in this series, being the only one in which the artist-subject is shown in multiple poses. (Fig. 12) She is dressed in the iconic *Mbopo* regalia worn by Ibibio maidens who have undergone the Nkugho ritual, a rite of passage com-mon to Ibibio and Efik peoples of the Cross River region of Nigeria. The Ibibio

12 *Ndise Mmi (self-portrait)*, 2013
Series of 8 images
C-print on Dibond, 24 × 36 in.

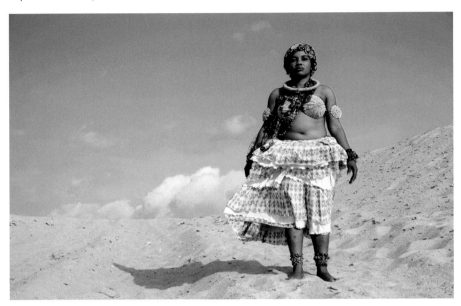

term for this practice, *ekuk mbopo*, is erroneously translated into English as "fattening room." While it is true that women who complete the ritual gain weight, *mbopo*'s primary purpose is to prepare young maidens for womanhood and marriage. In Ibibio culture, corpulence is viewed as a sign of prosperity, fertility, and beauty. The maiden is secluded for a month and fed rich foods while receiving instruction from elderly women in the community on marital etiquette and social customs associated with womanhood. At the end of this period of seclusion, the maiden is revealed to her community clothed in immense finery and performs a dance. *Mbopo* thus represents Ibibio/Efik ideals of female beauty and morality.

Udondian's self-representation as a figure of Ibibio/Efik feminine ideals is succinctly captured in four photographs. In the first photograph, she stands on a dune, facing the camera, wearing a neck ring, arm decorations, and brassiere all made out of wicker basketry, a close-fitting headdress made of beads, amulets, carved shells, and a circular forehead mirror. A beaded collar and several strings of beads complement her neck-ring along with beaded wrist-bands and ankle bracelets. A voluminous skirt with yellow ochre and white patterns completes the ensemble. The artist is posed in the right-hand section of the photograph, staring off into the distance. The second photograph is enlarged from the first to show only the artist's head and torso centered in the image field. In the third, Udondian is shown standing on the left-hand side of

the photograph, still wearing the same regalia but with her breasts exposed, the wicker-basket brassiere noticeably absent. The sand dune cuts an ascending diagonal from left to right parallel to her billowing skirt. In the fourth photograph, Udondian stands with her back to the camera, her bare back enhancing the beads and circular shells decorating her headdress.

The *Arti-tude* project is composed of these nine self-portraits, collectively titled *Ndise Mmi (self-portrait)*, and an installation titled *Fog of Colours* showing a gallery space with the self-portrait photographs displayed in thin white frames. (Fig. 13) Nine individuals, eight women and one man, are dressed in the regalia shown in the portrait and arranged on a central platform covered in a quilt of used clothing in various shades of green. The man and one woman are white, the other models black, and Udondian is present in the tableau only in her self-portraits hanging on the wall. The man and a female model wearing the Fulani milkmaid regalia are both standing: he in the middle of the group and she standing at the front right-hand corner of the platform. A female model in Udondian's Ibibio maiden regalia perches at the left-hand corner of the platform, while another dressed in Nkugho finery (the Efik version of Ibibio Mbopo) and holding a scepter sits in a regal manner in the foreground center of the platform. Models wearing the Benin queen and Igbo woman attires sit in a line in the background along with a female model in male Yoruba clothing. In the front left-hand corner, Sisi Eko sits off-platform, away from the rest of the models, and stares at various documents arrayed on a table in the foreground.

The *Fog of Colours* installation thus shows Udondian creating hybrid costumes embodied by a diverse cast of individuals. Activated through performance and photography, her models function as sculptures installed in space. When these models are present, they energize the exhibition space by their ritualized poses and interactions as they sit, stand, move toward and around the other models. In their absence, the central platform is animated by its multiple shades of green and the plinth forms of the rectangular boxes upon which some of the models are seated. It is important to mention that the clothing worn by these models was fabricated using specific materials: for example, the Fulani attire was made from second-hand men's underwear, while the red wraparound Benin attire was made from used T-shirts.

Ethnically dressed subjects of the kind represented in Udondian's self-portraits have been a favored theme in modern Nigerian art since they first showed up in the paintings of pioneers Akinola Lasekan and Ben Enwonwu. Their subsequent use by younger artists to signal "Africanness" has become something of a cliché. Udondian subverts such representations by presenting herself as the embodiment of various Nigerian cultures, thus deconstructing

13 *Arti-tude: Fog of Colours*, 2013
Life sculptures, mixed fabrics, wood, second-hand clothing, archival photos
Dimensions variable
Image credit: Courtesy of the artist

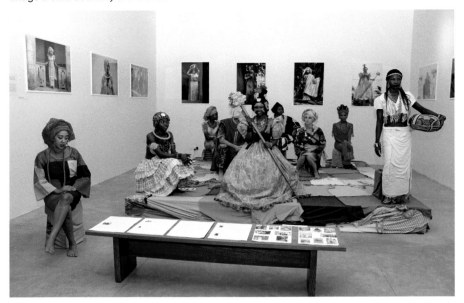

the notion of cultural specificity. Although her self-representation as an Ibibio maiden shows the artist fully engaging her own ethnic origins, the wicker-basket bra and armbands of her ensemble satirize essentialist ideas of African culture and thereby critique *National Geographic* norms of African primitivism.[26] She further opens up entrenched definitions of who is Nigerian (or African) by including two persons of European ancestry among the individuals she chose to model these ethnic regalia. Interestingly, both of them wear matching Yoruba wedding attire. Udondian's self-portraits question essentialist notions of ethnicity by presenting herself as a collective of Nigerian ethnic identities. *Fog of Colours* builds on this relationship between individual and collective identity by using human sculptures of different races performing in hybridized garments to explore the implications of establishing ethnic or racial identity through ethnic attire. The contemporary relevance of this issue can be seen in a recent media spat surrounding the use of Qipao, a Chinese-style attire, as a prom dress by Utah high-school student Keziah Daum.[27] The charges of appro-priation leveled in the ensuing debate often resorted to essentialist arguments that correlate ethnic regalia with individual and ethnic identity.

Udondian's portrayal of the artist-subject through the medium of self-portrait photography centers the question of how subjectivity is established and how meaning is made in relation to representations of the human body. Her accumulation of ethnic identities through self-portraiture is an act of

embodiment, a form of photographic practice in which the subject performs the self within the purview of an apparatus of perspectival looking that freezes the body as representation.[28] Her multimodal protocol of self-representation comprehends the lived body "as an assemblage of practices, discourses, images, institutional arrangements, and specific places and projects."[29] Meaning, in this regard, is historically and culturally contingent.

Amelia Jones describes the photographic self-portrait as a *technology of embodiment* that allows artists to "play out the instabilities of human existence and identity in a highly technologized and rapidly changing environment" by performing the self through photographic means.[30] Jones notes that self-portraiture differs from portrait photography in general: "In the portrait image of any kind, a subject is apparently revealed and documented. In the self-portrait, this subject is the artist herself or himself, and the promise of the artwork to deliver the artist in some capacity to the viewer, a promise central to our attraction to images, is seemingly fulfilled."[31] However, in the same manner that Udondian's appropriation of multiple Nigerian ethnic identities undermines essentialist notions of ethnicity, the photographic self-portrait undermines the promise of fulfillment through an exaggerated performativity that makes it clear we can never know the subject behind or in the image. Jones suggests it "complicates the belief in the self-portrait image as incontrovertibly delivering the 'true' artistic subject to the viewer—a belief central to modernist discourses of art and photography."[32] The photographic self-portrait is therefore a special case. By imaging her/him/their-self, the artist opens up a range of critical possibilities in terms of the circuits of making and viewing that constitute visuality itself. In this regard, Udondian's photographic self-performance in the *Arti-tude* project establishes what Jones describes as "an exaggerated mode of performative self-imaging that opens up an entirely new way of thinking about photography and the racially, sexually, and gender identified subject."[33] The artist invites us to think beyond essentialist notions of African identity in order to see how the tension of pose and performance in self-portrait photography exposes the embodied subject as a mask or screen.

ANCHORING DRIFT: THE REPUBLIC OF UNKNOWN TERRITORY

Location, identity, migration, and memory all emerge as central issues in the art of Victoria-Idongesit Udondian. They reflect the artist's belief that the entire fabric of the contemporary is transtemporal and transterritorial. This speaks less to movement from one location to another than to the networked nature of

14 *The Republic of Unknown Territory*, 2017
Performance and multimedia installation
Dimensions variable

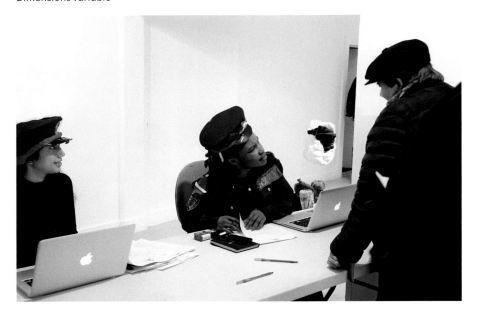

contemporary interactions that reflect how the present emerges from a history of dense exchanges. But as we noted earlier, migration for African contemporary artists is fraught with difficulties, and these have compounded in the era of global pandemics. COVID-19 broke the world. The enforced localization engendered by the pandemic presaged the end of globalization as we know it. In its place, cold winds of intolerance, authoritarianism, and revanchist nationalism are blowing across America and Europe. Udondian notes she is compelled to respond to notions of border security and immigration as an artist from Nigeria who must often deal with the frustration of constantly having to go through rigorous visa application processes to travel anywhere in the world.[34] Denied access to international venues and sites of practice, African and black artists like Udondian are cast adrift on the global flow of contemporary art as undesirables.

The above concerns frame Udondian's ongoing project titled *The Republic of Unknown Territory*, which she started working on during a 2016–2017 residency at the Fine Arts Works Center in Provincetown, Massachusetts.[35] *Republic* is a multimedia installation and performance project that interrogates the nature of borders, immigration, and privilege by simulating and recontextualizing the experience of obtaining a visa at a customs office for American audiences. (Fig. 14) The performance project recreates the tedium and frustration of the visa application process by requiring the exhibition attendees to fill out an adapted version of the Nigerian US visa application form, which contains

deeply intimate questions ranging from one's sexuality to one's income, in order to gain access to the art exhibit. Without access to comforts like chairs, participants were made to bear the discomfort of waiting as they experienced the arbitrariness of immigration bureaucracy.[36] Approval and denial of admission to the exhibition are granted according to the subjective whim of the custom officer, played by Udondian herself. By reversing the paradigm of travel and the constraints of borders, the exhibit opens American audiences to the experience of being prohibited to enter desired territories.

The Republic of Unknown Territory explores migration through absence: elements of the exhibition include hundreds of disembodied shoes, floating hijabs, open suitcases with clothing spilling out, all parted from their owners. The hijabs reference the demonization of peoples of Islamic ancestry whose difficulties with international travel were compounded in the age of the US-led "war on terror" (Global War on Terrorism—GWOT, 2001–2021). The exhibition also included the artist's Nigerian passport prominently displayed on a pedestal, a far cry from how international immigration officials treat holders of such passports with disdain at international borders. (Fig. 15) However, the most interesting element of the performance project was not its constituent exhibits, but the reaction of certain attendees who saw the artist's arbitrary decisions to deny them access to the exhibition as an affront. Udondian narrates the story of an older white man who was particularly incensed by being denied a visa and

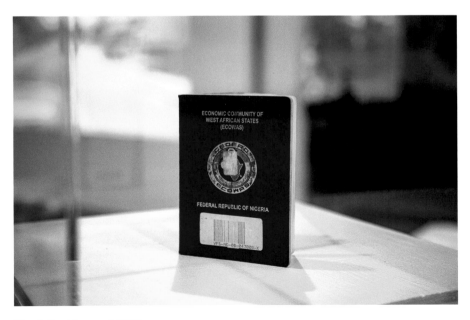

15 *Retired Passport*, 2016
Nigerian passport, constructed vitrine, wood, Plexiglas, 51 × 13 in.

attempted to force his way into the exhibition, relying on his white privilege to subvert both the aims of the exhibition and the efforts of security guards to dissuade him. Of course, a similar insistence by an African migrant at the United States Embassy in Nigeria would result in the person being barred from ever applying for a US visa again or, more likely, in arrest and imprisonment.

Udondian's performance thus successfully illustrates how precarious the process of travel is for Africans and critiques the lack of knowledge about this issue among the American audience at her exhibition. As usual, she worked with immigrants and immigrant groups in the US to collect their stories and experiences, which were edited into a video and sound installation included in various iterations of the installation. This aspect of the performance project seeks to highlight the important contributions of immigrants to the social and racial tapestry of the nation. Udondian notes that the project is expansive and can be reconstituted in various countries to interrogate each locale's relationship with migrants from Africa, and would have a major impact when presented at the capitals of Africa's former colonizers.

CONCLUSION

Victoria-Idongesit Udondian's artworks are sophisticated interrogations of contemporary African identities in art and global relations. Recent efforts to define new contemporary African sensibilities are bogged down by the stubborn persistence of discourses of the nation, identity, traditional canons, and artistic conventions that restrict the creativity of African artists. These greatly limit how public discourse engages the new generation of international artists from Africa who chafe against the constraints of such notions. Udondian pushes the conceptual and material boundaries of local and global artistic standards by making art that intentionally questions and critiques the meanings and forms behind these often oppressive discourses. She does not subscribe to restrictive terms of definition such as "Afropolitan," "post-black," or any of the plethora of untenable propositions that seem interested in divorcing contemporary African artists from the reality of Africa's long history of creativity, cultural identity and artistic practice. Instead, she draws on this legacy and argues for its place in the multimodal context of her contemporary art in which used clothing, as an item of charity and commerce, binds Italy and Africa together; performative self-portraiture destabilizes notions of essentialist African identities, and critiques of immigration policies imbricate the USA and Nigeria in a tragicomedy of truncated expectations. The resulting work is significant, and it fills important gaps in our understanding of African identities in global contemporary art.

1 Victoria-Idongesit Udondian, *How Can I Be Nobody*, Smack Mellon, New York, March 5 – April 10, 2022, https://www.smackmellon.org/exhibition/victoria-idongesit-udondian-how-can-i-be-nobody/# (accessed May 17, 2022).

2 The Efik language is spoken by indigenous Efik peoples in the Cross-River region of Nigeria and northwestern Cameroon.

3 The slave ship *Brooks* diagram is infamous for its illustration of a slave ship loaded to capacity with its cargo of 454 Africans crammed into the hold for the transatlantic voyage to the Caribbean. See https://www.bl.uk/collection-items/diagram-of-the-brookes-slave-ship (accessed July 8, 2022).

4 The United Nations High Commissioner for Refugees estimates that more than 21,500 migrants have died in the Mediterranean since it began keeping track in 2014. At least 75% of the dead are Africans. See https://www.unhcr.org/en-us/news/briefing/2022/6/62a2f90a1a/unhcr-data-visualization-mediterranean-crossings-charts-rising-death-toll.html (accessed Nov. 19, 2022).

5 See Marcus Rediker, "History from Below the Water Line: Sharks and the Atlantic Slave Trade," *Atlantic Studies* 5, no. 2 (August 2008): 285–97, doi: 10.1080/14788810802149758. See also Karl Leif Bates, "Group Urges Atlantic Seafloor Be Labeled a Memorial to Slave Trading," *Duke Today*, November 10, 2020, https://today.duke.edu/2020/11/group-urges-atlantic-seafloor-be-labeled-memorial-slave-trading (accessed April 16, 2022).

6 Sophie Sanders, "Sonya Clark: Constellations of a New American Canon," *Nka: Journal of Contemporary African Art*, no. 50 (May 2022): 146–58. Sanders (p. 146) uses this concept to investigate the works of Sonya Clark, whose fiber installations and performances, like those of Udondian, examine the past and present from personal, cultural, and ethical perspectives.

7 The difficult bureaucratic process and its effect on African travelers are documented in a series of posts by Sylvester Okwunodu Ogbechie titled "Borders and Access" on the blog *Aachronym.blogspot. com*. See especially "Borders and Access 5: Crossing," *Aachronym*, October 23, 2007, http://aachronym. blogspot.com/2007/10/borders-and-access-5-crossing-part-i.html?q=borders+and+access.

8 Victoria-Idongesit Udondian, *How Can I Be Nobody*.

9 For the specific role of cotton in this context of trade, see Colleen E. Kriger, *Cloth in West African History* (Lanham: AltaMira Press, 2006).

10 Willem Schinkel, "To Decolonize Migration Studies Means to Dismantle It: On Adrian Favell's *The Integration Nation* and Question-ability," *Ethnic and Racial Studies* 46, no. 8 (2023), 1600–08, doi: 10.1080/01419870.2022.2130704.

11 See Hein de Haas, "The Myth of Invasion: The Inconvenient Realities of African Migration to Europe," *Third World Quarterly* 29, no. 7 (2008), 1305–22, doi: 10.1080/01436590802386435.

12 Giorgio Agamben, *Homo Sacer: Sovereign Power and Bare Life*, trans. Daniel Heller-Roazen (Redwood City, CA: Stanford University Press, 1998).

13 Amy O'Donoghue, "Sovereign Exception: Notes on the Thought of Giorgio Agamben," *Critical Legal Thinking: Law and the Political* (CLT), July 2, 2015, https://criticallegalthinking. com/2015/07/02/sovereign-exception-notes-on-the-thought-of-giorgio-agamben/ (accessed Nov. 3, 2022).

14 Victoria-Idongesit Udondian, *How Can I Be Nobody*.

15 The Nsukka School refers to a cluster of contemporary artists from the University of Nigeria Nsukka and adjacent art institutions in Enugu. For a detailed history of this movement, see Simon Ottenberg, *New Traditions from Nigeria: Seven Artists of the Nsukka Group* (Washington, DC: Smithsonian Institution Press, 1997).

16 Holly Black, "Victoria-Idongesit Udondian: How El Anatsui Reshaped my Awareness of Art Materials," *Elephant*, May 19, 2022, https://elephant.art/victoria-idongesit-udondian-how-el-anatsui-reshaped-my-awareness-of-art-materials-19052022/ (accessed May 19, 2022).

17 For detailed analysis of this phenomenon, see Andrew Brooks and David Simon, "Unraveling the Relationships between Used-Clothing Imports and the Decline of African Clothing Industries," *Development and Change* 43, no. 6 (2012): 1265–90.

18 Dutch Wax "Hollandais" is spelled as "Hollandis" on Udondian's website. I have retained her spelling for this essay.

19 See Nina Sylvanus, *Patterns in Circulation: Cloth, Gender, and Materiality in West Africa* (Chicago: University of Chicago Press, 2016). See also *Vlisco: African Fashion on a Global Stage*, exhibition at the Philadelphia Museum of Art, April 30, 2016 – January 22, 2017, https://philamuseum. org/calendar/exhibition/vlisco-african-fashion-on-a-global-stage.

20 Sarah Archer, "How Dutch Wax Fabrics Became a Mainstay of African Fashion," *Hyperallergic*, November 3, 2016, https://hyperallergic.com/335472/how-dutch-wax-fabrics-became-a-mainstay-of-african-fashion/ (accessed Dec. 1, 2022).

21 Sarah Archer, "How Dutch Wax Fabrics Became a Mainstay of African Fashion."

22 Aura Seikkula and Bisi Silva, "Framing the Moment: The Independent Look of J. D. 'Okhai Ojeikere," http://www.africultures.com/php/?nav=article&no=11519 (accessed September 12, 2022).

23 Suzanne Blier, *Royal Arts of Africa: The Majesty of Form* (London: Laurence King Publishing, 2012), 35.

24 Victoria-Idongesit Udondian, *Arti-tude*, https://victoriaudondian.com/2013-arti-tude/.

25 Robert Farris Thompson, "An Aesthetics of the Cool," *African Arts* 7, no. 1 (Autumn 1973): 40–43, 64, 67, 89–91.

26 *National Geographic* has long faced criticism for its essentialist representations of Africans and non-Western peoples. For a critical analysis of its role in promoting primitivist ideas about indigenous cultures, see Catherine A. Lutz and Jane L. Collins, *Reading National Geographic* (Chicago: University of Chicago Press, 1993).

27 Amy Qin, "Teenager's Prom Dress Stirs Furor in U.S.—but Not in China," *New York Times*, May 2, 2018, https://www.nytimes.com/2018/05/02/world/asia/chinese-prom-dress.html (accessed August 3, 2023).

28 Amelia Jones, "The 'Eternal Return': Self-Portrait Photography as a Technology of Embodiment," *Signs: Journal of Women in Culture and Society* 27, no. 4 (2002): 947–78, doi: 10.1086/339641.

29 Margaret Lock and Judy Farquhar, eds., *Beyond the Body Proper: Reading the Anthropology of Material Life* (Durham: Duke University Press, 2007), 1.

30 Amelia Jones, "The 'Eternal Return'": 950.

31 Amelia Jones, "The 'Eternal Return'": 951.

32 Amelia Jones, "The 'Eternal Return'": 951.

33 Amelia Jones, "The 'Eternal Return'": 948.

34 Victoria-Idongesit Udondian, *The Republic of Unknown Territory*, https://victoriaudondian.com/the-republic-of-unknown-territory/.

35 Fine Arts Work Center, https://fawc.org/the-fellowship/.

36 Victoria-Idongesit Udondian, *The Republic of Unknown Territory*.

Aso Ikele (1948) (detail), 2011
Used clothes from Manchester, printed fabric, used burlap from Nigeria
296 × 280 in.
Image credit: Michael Pollard

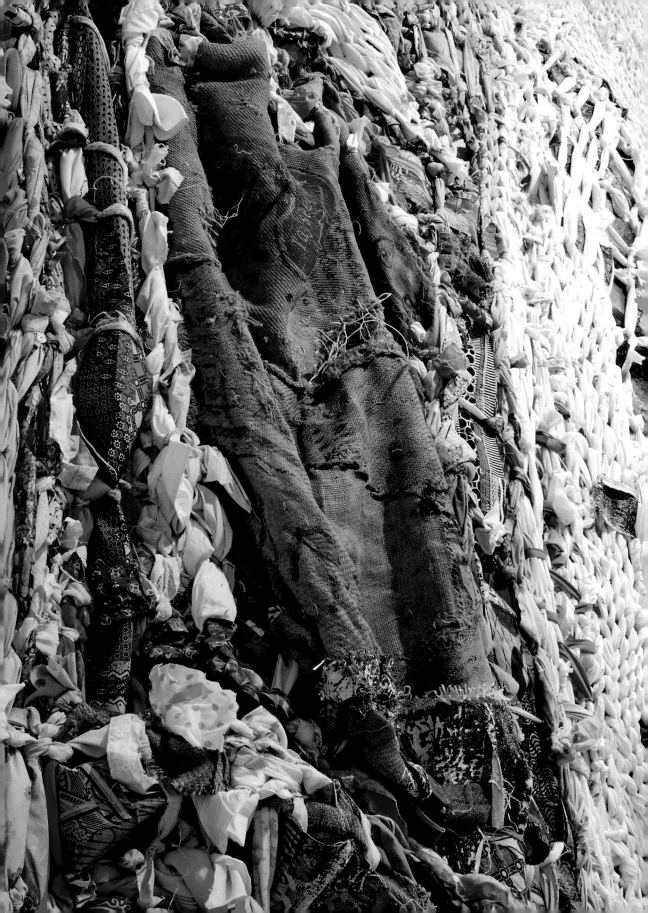

AYANNA DOZIER

FAST, FLACCID CAPITALISM IN HOW CAN I BE NOBODY

Victoria-Idongesit Udondian's rich textile-based, site-specific installation *How Can I Be Nobody* (2022) embodied and revealed the anonymity of the capitalist exploitation of garment industries. Featuring a staggering swath of mass-produced second-hand factory T-shirts draped across the industrial space of Smack Mellon's DUMBO gallery, Udondian used scale and quantity to materialize the physical labor of immigrant women of color across the soft capitalism of textiles.

Textile-based labor has long been overlooked in visualizations of labor because it does not evoke the physicality associated with the "hard labor" of mining and machine factory work that is often associated with a type of aggressive, phallic power. It is work that demonstrates the temporality of labor that is, as Angela Davis writes in *Women, Race, and Class* (1983), "the living, shaping fire … [that] represents the impermanence of things, their temporality."[1]

To not reinforce the same system of exploitation, Udondian paid her collaborators from Stitch Buffalo, a textile center that facilitates textile-based labor for refugee and immigrant women, to accomplish the laborious task of weaving, knotting, and yoking together second-hand T-shirts to create the immersive tapestries that were on display. She then had casts of their hands created to produce sculptures that indexed their bodies in the space of their labor. These sculptures were paired with audio recordings of her collaborators recounting their personal histories and narratives to Udondian.

The title of the installation comes from a question posed by one of Udondian's collaborators who feared that telling her story would place her community in danger. She asked Udondian, "How can I be nobody and tell you my story?"[2] This woman's desire for anonymity and self-expression is metaphorically mapped across the labor of garment work that erases the lived labor of immigrant women while fabricating marketing images of freedom to Euro-American women through the consumption of these objects.

Though firmly located in the throes of twenty-first-century culture, the twentieth-century push for the modern autonomous subject still governs our public imagination. It is a character that, as Raka Shome and Radha S. Hegde write, is "firmly entrenched in the dominant discourses on multiculturalism and often appears in the rhetoric of corporate multiculturalism" to "create a … work force who can 'skillfully' navigate cultural difference."[3] By emphasizing the autonomy of the singular subject, globalization does not create a utopian space of multicultural belonging but rather obfuscates the flows of objects, persons, images, and discourses that exist in a global context. These flows of cultural exchange in fact repeat the colonial pathways and collisions of Europe across Africa, the Caribbean, the Americas, and the Pacific islands.

Mass-produced garments, colloquially referred to as "fast fashion," reveal the terror of globalization in both its ability to reinforce individual "autonomy" through self-fashioning while also blocking the visuality of the circuitous colonial and exploitative travels of such garments. Part of capitalism's continued success, as Karl Marx argued, is its ability to strip the cost value of labor away from finished products, rendering all objects as possible surpluses or commodity fetish objects.[4] *How Can I Be Nobody* is a meditation on commodity fetishism for how Udondian materializes the oft-neglected labor of women in these industries. It is also a deeply feminist work. The installation, like Udondian's body of work, foregrounds how women bear the brunt of commodity fetishism across textile industries. Through the revealing horror stories of fast-fashion production warehouses like Shein, we see that poor women and immigrant women are the ones who make up the labor force that is shackled to never-ending workdays to meet excessive quotas.[5] Because capitalism rests on the exploitation of women, our precarity is often enforced by a structural system of gendered oppression that is mechanized to ensure the continual exploitation of women of color across the globe, specifically black and indigenous women.

Udondian came into this practice of upcycling second-hand garments through her lived experience and research. Growing up in Nigeria, Udondian was exposed to both the wastefulness of second-hand clothing crossing Nigeria's shorelines and an economic prosperity in which businesses curate and resell these garments. To Udondian, examining the history of second-hand clothes and how Nigerians used them to fashion their own identity (either in favor of, or in opposition to, Euro-American culture) is a way of tracing the ongoing exchanges between Europe and Africa that both are an aftereffect and a re-enactment of European colonization. As she stated in a 2020 artist talk, "Africa has always had to deal with the [impression] of the West upon it."[6]

In 2011, Udondian participated in a residency in Venice where she worked closely with charities that collect second-hand clothing. She noticed that not all the donations were redistributed to charitable houses in Italy; some went to a separate site that she was not permitted to access. She speculated that these other garments likely made their way to various ports in Africa and throughout the Global South to make up the second-hand clothing runoff that exists in those regions.[7]

At the culmination of this residency, Udondian presented the installation *Second-hand Museum* (2011). This piece led her to question the notion of historical accounts within museums, reconciling that each historical object is the result of someone's fabricated narrative. "When you think of the museum as a center in which history is being preserved … I was interested in how stories

become history, questioning the veracity of historical accounts through generating my own history."[8]

Udondian's large-scale tapestries in *How Can I Be Nobody* are not just woven structures of upcycled garments, but a living history of the labor of spoken and embodied women of color which shrouds ways of living and what is made possible in the public domain. Angela Davis reminds us that this, too, is conditioned by the exclusion of women of color from conversations on labor as well as by the normative thinking of "femininity" which prioritizes the labor concerns of Euro-American white women in the corporate world.[9]

The labor-intense and yet flaccid nature of working with textiles resists mainstream imagery and discourse of labor, which itself is a result of what Shome and Hegde define as the reality of globalization. The overlooked labor of textile-based work is fast fashion's commodity fetishism at its finest. As the title evokes, "How can I be nobody?" is also the process of disassociation with oneself, where one operates with no forward agency, flowing like water. (This is further reinforced through the numerous sea references throughout the piece.)

The process of becoming a nobody, of course, is the result an aggressive exploitative system of capitalism that prefixes flaccidity to some industries as less destructive than others; a result of its, to paraphrase bell hooks, imperialist white supremacist patriarchal bonds. Udondian reveals capitalism's self-constructed myth of soft labor through her process-oriented sculptures. Through fabrication across storytelling and weaving, she demonstrates the aggressive forces of garment industries that, despite their narrative of speed, have a long-lasting destructive impact on the lives of immigrant women of color.

1 Angela Davis, *Women, Race, & Class* (New York: Vintage Books, 1983), 11.

2 Ayanna Dozier, "Victoria-Idongesit Udondian Weaves the Stories of Immigrant Labor into Tapestry Sculptures," *Artsy*, April 5, 2022, https://www.artsy.net/article/artsy-editorial-victoria-idongesit-udondian-weaves-histories-immigrant-labor-tapestry-sculptures.

3 Raka Shome and Radha S. Hegde, "Postcolonial Approaches to Communication: Charting the Terrain, Engaging the Intersections," in *International Communication: A Reader*, edited by Daya Kishan Thussu (New York: Routledge, 2009), 99.

4 Karl Marx, *Capital: A Critique of Political Economy*, edited by Frederick Engels (New York: A Modern Library, 1906), 71.

5 Wu Peiyue, "The Shady Labor Practices Underpinning Shein's Global Fashion Empire," *Sixth Tone*, September 17, 2021, https://www.sixthtone.com/news/1008472.

6 Victoria Udondian, "UB Visiting Artist Speaker Series," University at Buffalo, Buffalo, NY, September 28, 2020.

7 Ibid.

8 Ibid.

9 Davis, *Women, Race, & Class*, 17.

MOYO OKEDIJI

VICTORIA-IDONGESIT UDONDIAN: FACE-TO-FACEBOOK ART TALK

THE UNIVERSITY OF AFRICAN ART is proud to present VICTORIA-IDONGESIT UDONDIAN in conversation on Tuesday, May 31, 2022 at 10 a.m. USA Central Time.

MOYO OKEDIJI: We welcome our special guest, Victoria-Idongesit Udondian, to this discussion today. Good morning to you.

VICTORIA-IDONGESIT UDONDIAN: Thank you. I am excited to be here.

MO: Where are you? I am in Austin, Texas.

VU: I am in Buffalo, New York, at the moment.

MO: OMG! Buffalo, New York, has been in the news lately about the grocery store shooting. Have you been following that story?

VU: Yes! The store is barely an 18-minute drive from where I live. It's been very heart-wrenching.

MO: I'm so sorry to hear that. Many people I talk to say they don't pay close attention to the news because it has been so depressing for such a long time now. As an artist, what do you think about paying attention to the news? Do we just tune out the news so that we don't get depressed?

VU: I do tune out a lot of the time, but this one got me when all my friends reached out to check if I was safe. Getting on the news the day after to watch the families of the victims, as well as the survivors, narrate their experiences really broke my heart and with the recent school-shooting situation in Uvalde [Texas], I am trying to tune out again for my own sanity, but I can't help myself as I keep going back. My thoughts and prayers are with the families affected directly.

MO: Your work engages social issues. How do you balance the act of turning off the news with engaging things happening in the community?

VU: That's a great question, prof. At a time, I used to listen to *Democracy Now!* on NPR (National Public Radio) every morning to stay informed with happen-stances around the world, but over time I realized how the constant infiltration of demoralizing news impacted the start of my day. I had to stop. I take in as

much as I am able to and turn it off, as my mental health is most important if I must keep at my work. I am not a TV person, which helps. Most of the issues I confront in my works have always been there, and current events just reinforce the urgency that I feel towards addressing them. Moreover, it doesn't take much these days to know what's happening, as our gadgets, phones, and laptops will find a way to deliver unsolicited breaking news to you.

MO: Can we discuss your latest project, *How Can I Be Nobody*? The installation was at a gallery in New York. When and why did you start thinking about the project?

VU: *How Can I Be Nobody* is a project I have been working on for the past two to three years. It was my first collaborative project with immigrant communities in the New York area, where I lived and worked during this time period. My interest in addressing notions of immigration and border control came from my frustration with dealing with these systems at the onset of my own naturalization process in America. I mean, it was 2017, and the administration at that time was consumed with constant vilification of immigrants and refugees. I was moved to respond, first by creating *The Republic of Unknown Territory*, which we can talk about in a moment, and then by opening up my studio to collaborate with folks with the same lived experiences to share their stories while creating the works together. *How Can I Be Nobody* comprises large handmade woven textiles, sculptures, and sound recordings. One of the pieces presented as part of this project was titled *Mme Anam Utom*, which is an Ibibio word that translates as "the workers"—the laborer, if you will. *Mme Anam Utom* was made with used coats and epoxy resin. Through an exchange process, my collaborators were asked to donate their used work clothes, preferably in black, in exchange for new ones. These collected clothes were frozen into forms that referenced the bodies of their owners in fallen shapes. Installed on the floor, the forms allude to the repressive, exploitative conditions faced by workers within labor systems and other contexts of neocolonial conditioning.

MO: I really find the process you have described for creating *How Can I Be Nobody* fascinating, and your description of it as woven sculpture, a collaborative installation of community storytelling. Do you remember the places where these immigrants came from? What drove them to leave their original homes? What did they experience as they crossed to their present homes? What are they experiencing now?

VU: For *How Can I Be Nobody*, my collaborators came from different places and diverse fields. I had college professors, scholars, lawyers, artists, and several women who had fled wars and other inimical social conditions from Burma, Pakistan, Uganda, etc.; first-generation Americans whose parents had immigrated here for several reasons; black Americans whose families had moved from the South during the Great Migration. As part of this project, I did collect stories. This collection of sound interviews from my collaborators who included displaced women, men, refugee women (for lack of a better word), and migrants who have all migrated, forcefully or voluntarily, from their homes for numerous reasons was presented as part of the ship rib (*Ubom Keed* and *Ubom Iba*) sculptures.

> MO: Victoria-Idongesit Udondian, *Ubom Keed* and *Ubom Iba* sound like indigenous names to me. What do they mean?

VU: Yes! *Ubom* is an Ibibio word that translates as "ship" or "canoe," while *keed* and *iba* are numbering in Ibibio as well, a Nigerian language from the south of the country, which is my mother tongue. *Keed* translates to "one" and *Iba* to "two."

> MO: It is remarkable that you use second-hand clothing from the West worn in Africa as "power objects." The use of second-hand clothing, as you mention, is a development that came with colonization. But it's not just used clothes from the West. It is used everything, including electronics, tools, automobiles, computers, cell phones, and all other things. What is your attitude toward the place of Africa as consumers of discarded stuff from the West?

VU: I have long critiqued Nigeria's overdependence on foreign goods, the second-hand clothes being an example of that industry. My older works back in Nigeria were really about researching the origins of these industries and the impact they've had on the local economy as well as on cultural identities, taking into account the huge decline in the Nigerian textile production industries from the 1960s to date. But as an artist, I am also interested in material histories and how the social life of an object impacts its intrinsic value.

> MO: The ship has levels of meaning for you. What is the significance of the ship among the Ibibio people, your indigenous group in Nigeria, vis-à-vis their contact with people from the West? Is the ship sinking, rocked in

troubled water, or where do the Ibibio people stand today in the order of things?

VU: The ship, in the context of this project, was constructed from the model of the *Brooks* slave ship as a way to bring slave history as a forced migration into the conversation, since some Efiks and Ibibios were victims of the slave trade as well. According to the Library of Congress website article "A Journey in Chains" (https://www.loc.gov/classroom-materials/immigration/african/journey-in-chains/), *"To the slave traders, these human beings were cargo, and slave ships were especially designed to transport as many captives as possible, with little regard for either their health or their humanity. Slave decks were often only a few feet high, and the African captives were shackled together lying down, side by side, head to foot, or even closer. Deaths from suffocation, malnutrition, and disease were routine on the slave deck, as were arbitrary torture and murder by the crew. The closeness, the filth, and the fear delivered many into madness, and suicide attempts were common."* The *Ubom* sculptures embody these histories as the ship becomes a signifier for commerce, imbued with all the history of slavery while also considering the numerous migrant ships that languish and flounder in the Mediterranean Sea. The two ships I included in the exhibition were suspended in space, but elements of the installations—the hands, the shoes, and the clothes—were sinking in some part. This installation aims to encapsulate the risks that most of these migrants take as they seek better living conditions and the price many of them pay. Most do not survive their journey as they attempt to make this crossing of artificial borders, drawn with colonial authority.

MO: You must have studied conventional mediums of art-making in Nigeria, such as figure painting, sculpture and ceramics. I doubt installation art was part of your training in college. How did you become interested in fiber art?

VU: My first degree was in painting, as you rightly suggested, from the University of Uyo in Nigeria, but my very first training after high school, though informal, was in tailoring and fashion design. Of course, my earlier works post-bachelor's degree were in very traditional painting styles. As time went on, I began to question my relationship to painting, as I didn't find myself within the Western painting histories that I had been taught in school. In seeking out materiality for engagement, textiles came to me naturally, as I was already working in textiles while tailoring clothes. Lastly, my MFA at Columbia University was

How Can I Be Nobody installation shot

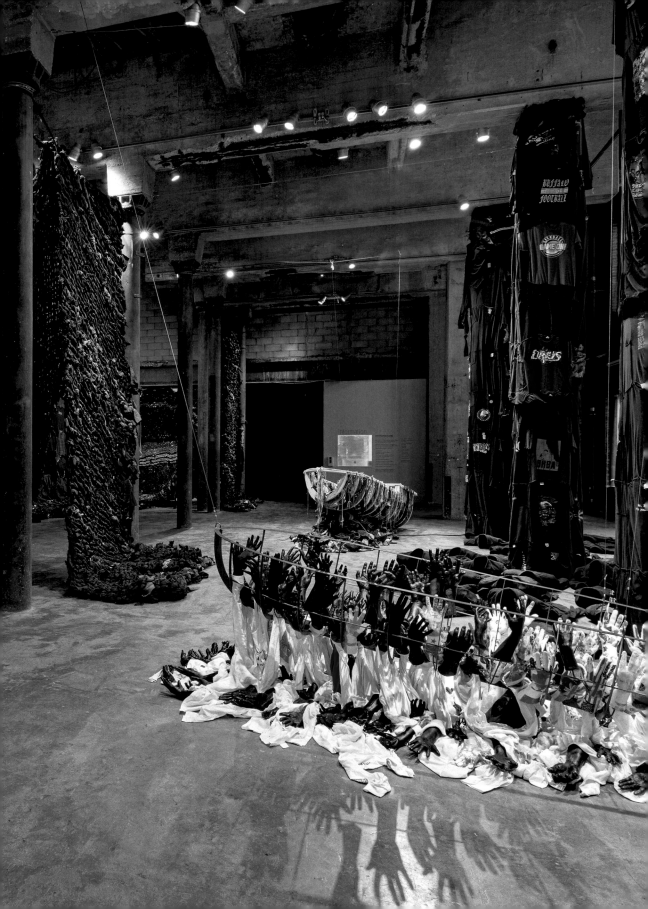

in sculpture and new genre through a very interdisciplinary pedagogy. All these trainings at various stages of my career have shaped and informed my practice, as my recent works and projects are interdisciplinary.

MO: Please provide us with some biographical details. Where and when were you born? Where were you schooled? Why did you become an artist? What is the present focus of your art, and what you want your audience to take from your work? Where do you want to sail the ship of your art in the future?

VU: I was born in Uyo, Akwa Ibom State, in the south of Nigeria. My early education was in a nursery and primary school within my state of origin, and my secondary education was at a Catholic boarding school: Immaculate Conception Secondary School, Itak, Ikono, Akwa Ibom State. I obtained my first degree from the University of Uyo with a BA in painting, and ten years after graduating, I went for an MFA in sculpture and new genres at Columbia University in New York City.

I have always been an artist. I was that kid who would draw everywhere in the house and make things with my hands, sewing, etc. Therefore, my parents enrolled me in tailoring while waiting for my West African Examination Council (WAEC) result to get into college. I recall when I was in primary four or five, at about seven to eight years old, I participated in an art competition in which I represented my school. I made a painting for the competition. I remember bringing the work home to finish and running out of paint. My parents had to go out late that night to the stores to find poster colors for my painting. I was blessed to have parents who supported me and provided the guidance I needed. Even when I was uncertain about studying art in college, my parents never lost sight of my natural inclinations and provided the needed guidance. My practice is dedicated to my parents for these reasons.

In my work, I combine traditional modes of making and craft practices that I learned naturally growing up in Nigeria with contemporary art-making sensibilities to create large-scale interdisciplinary projects. I am interested in the intersectionality between labor, global trade systems, postcolonialism in the context of globalization, and its impacts on local economies as well as cultural identities.

I am not sure my work has the capacity to change the world, but I hope that projects like *How Can I Be Nobody* will serve as a platform to drive conversations around the issues the work raises: issues such as migration, labor systems, colonialism, etc. Presently, having wrapped up this large-scale instal-

lation, I'm focused on reading and revisiting aspects of my works that I think were not exhausted. For the remainder of the year, I will be working on smaller-scale pieces that need my attention while also pursuing funding for my next major artistic endeavor. If I should divulge just a titbit, the next project questions notions of Afro-Sino relationships, building upon my previous works that question Africa's colonial history and cultural identity. I will be delving into ceramics, and I am very excited to share this new project with the world.

MO: Victoria-Idongesit Udondian, please tell us about *The Republic of Unknown Territory*. What does that mean?

VU: *The Republic of Unknown Territory* was my first project that addressed notions of immigration and border control. The project was first performed and installed at the Hudson D. Walker Gallery during a solo exhibition that wrapped up my seven-month residency at the Fine Arts Work Center (FAWC) in Provincetown, Massachusetts, USA. With the cold wind of intolerance, authoritarianism, and nationalism blowing across America and Europe, with Trump's presidency at a time banning refugees and citizens of several Muslim nations, along with the outrage of legal visa and green-card holders being denied access to the United States, I felt compelled to respond to notions of border security and immigration. As an artist born in Nigeria, I must often deal with the frustration of trying to gain access to the world. I am constantly required to go through rigorous visa application processes to travel anywhere in the world.

Against this backdrop, I started working on a project called *The Republic of Unknown Territory*, a multimedia installation/performance project that interrogates the nature of borders, immigration, and privilege by simulating and recontextualizing the experience of obtaining a visa at a customs office for American audiences. The idea of this exhibition was to move deeper into this question of immigration by exploring the technical and often convoluted process of getting a visa when one is born in a post-colonial country. By confronting viewers with the extensive and haphazard application process, American audiences were able to experience the humiliating, illogical hurdles one must overcome to receive something as simple as a tourist visa to enter the United States. Even before Trump's ban, travel for many people around the world has involved extraordinary patience and determination while dealing with a cryptic and mystifying bureaucratic system. For many Americans, this was the first time they had ever applied for a visa, and through the exhibition, we witnessed the measures individuals will take to cross borders.

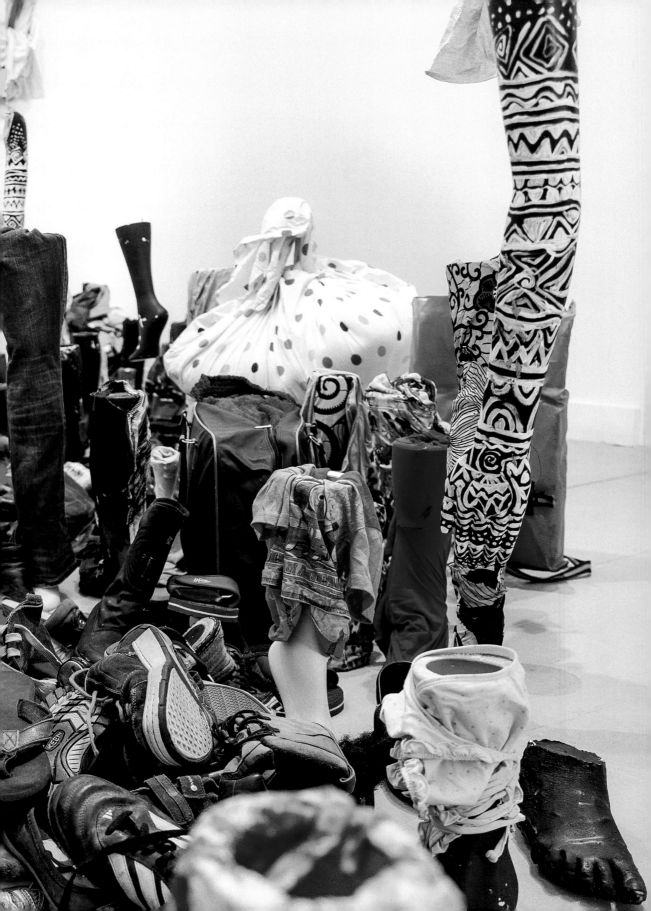

In a bid to recreate the tedium and frustration of the process, the piece required applicants to fill out an adapted version of the US visa application form used in Nigeria with its deeply intimate questions ranging from one's sexuality to one's income to gain access to the art exhibit and to the "Republic of Unknown Territory." Without access to comforts like chairs, participants must bear the discomfort of waiting as they experience the arbitrariness of the bureaucracy, where there are no right answers to questions. An individual might have too little money to enter the republic, or he/she might have an excessive amount. While performing as a customs officer along with a colleague, I granted approvals according to my own subjective whims. This reversal of roles allows me to sit in the space of power and reconfigure the dynamics of colonialism within the confines of the gallery space.

Only a few participants were granted access to the republic and the art exhibit, heightening the tension for those who were denied. The art exhibit in the gallery space titled *"Akauke"? Unknown!* was a large-scale installation piece that externalizes migration through absence: hundreds of disembodied shoes, life-cast feet, floating hijabs, and open suitcases with clothing spilling out. Simultaneously, the exhibition alludes to the anonymity of the countless migrants passing through countries in the hope of better lives while also referencing the many refugees who do not survive the journey. This installation was accompanied by collected stories and objects from immigrants around New York City that were compiled into a soundscape culminating in the *How Can I Be Nobody* exhibition.

During the opening performance, food and drinks were within the main gallery, which gave visa holders another level of privilege. Refusing the "denied" visa applicants any form of sustenance, I wanted to further create an atmosphere of desperation. During the performance at the Fine Arts Work Center, I did not expect individuals to disobey the laws of the republic. Some participants tried to cross into the exhibit by climbing onto the "roof"; others simply barged in by running through the barrier, which the border officers tried to stop. Eventually, those that were granted access opened the back gallery emergency exit door to give access to some who had been denied entry, after numerous attempts to pass drinks across the border. The performance, which lasted about an hour and a half, ended with a huge infiltration of illegal immigrants into the territory. Reversing the paradigm of travel, the exhibit opened American audiences to the experience of being prohibited to enter. The video documentation of this performance was also on view as part of the *How Can I Be Nobody* exhibition.

Akauke (detail), 2017, Multimedia installation
Used shoes, clothes, life cast of migrants' and the artist's feet,
used life jacket, sound recording
Dimensions variable

MO: That is such an amazing experience. I can identify with it. Interestingly enough, US citizens do suffer the effects of the difficulties that those attempting to enter the US experience. As a naturalized US citizen, I was made to go through a relatively difficult experience when I applied for a visa to Ghana. Because of the stringent measures that the embassy of Ghana designed in retaliation for US citizens applying for visas to Ghana, I ended up missing my flight because my visa did not arrive on time. It meant that I lost a lot of money. I would have loved to see your performance.

VU: I would like to see more of these retaliations. There are not enough of them out there, as American passport holders can travel to lots of countries without visa requirements. I'm sorry you had to go through that with the Ghanian embassy, but, well, use your Nigerian passport the next time in ECOWAS countries so that you don't pay a penalty for the "American privilege." Here is a link to a short clip of the performance video: https://www.youtube.com/watch?v= LZEoVe6YfhE.

MO: *How Can I Be Nobody* contains collaborations with performance artists. Who are these performance artists, and what is the significance of their contributions to the project?

VU: As part of the project, I was interested in activating the installation with performance. Undertaking a collaborative approach that was integral to the overall project, I collaborated with choreographer and dancer Danion Lewis to generate movement in response to the pieces to activate the immersive installation, addressing the exhibition's themes of migration, labor, and emancipation through visibility. The performance titled *Nsi nam mi ke ndi owo* was a one-time performance and the final event to take place in conjunction with the exhibition *How Can I Be Nobody,* which was on view from March 5, 2022 through April 10, 2022 at Smack Mellon gallery in New York. The performance's title is the Efik translation of the exhibition's title, relating acts of translation to visibility and bodily movement. The performance also featured costumes I had hand-designed, an adaptation of the installation, and movement by dancer Raven McRae.

MO: You told me you have seen the works of Belkis Ayón and Otobong Nkanga. Both women explore indigenous traditions similar to yours. Could you say a word or two about their works in comparison with your own?

VU: The two artists in question are artists whose works I have appreciation for. Nkanga is interested in the politics of land and its relationship to the body. Though not bound by media, she engages the archives and various modes of drawing, painting, photography, performance, and installation in trying to understand how land and its natural resources are entwined with colonialism, greed, pain, hope, and knowledge. Reflecting these in material objects as much as in intangible elements, Otobong weaves in these complexities in ways similar to how I examine the complexities of migration and racial/cultural identity in the global context.

Belkis Ayón's sheer mastery of materials and techniques in collography is mind-blowing. When I think of Ayón, like when I think of contemporary artist El Anatsui, their labor-intensive working process stands out to me, which is exhibited in the multiple matrixes of her prints as well as in Anatsui's sculptures. As an artist who creates large-scale, labor-intensive pieces in my textile artworks, I find these artists inspiring and a constant reminder that when it comes to process, one doesn't need to rush. Patience is golden.

MO: Finally, your influences?

VU: There are artists whose work I respect and have found inspirational. I recently had an interview published by *Elephant* magazine where I spoke about El Anatsui's influence on my practice, mostly in rethinking materiality and the notion of sculptural forms as malleable, layered, and fluid. Here is the link to the article: https://elephant.art/victoria-idongesit-udondian-how-el.../. Afi Ekong has been the female artist from my region, Ibibio/Efik, whose voice was heard as an artist beyond Nigeria. I find her very inspiring since it's difficult to come across female artists from modern Nigerian art history, let alone one who has worked internationally. I mean, the Nigerian art scene is very male-dominated even today. I would like to add Louise Bourgeois and Senga Nengudi to this list and Sheila Hicks, whose talk I attended recently and was so blown away by her brilliance as well.

AKIL KUMARASAMY

WHAT IS IT TO BELONG?

What is it to belong? It is this word—*belong*—that Udondian stretches out across time and space. In *How Can I Be Nobody*, we find belongings—second-hand clothing tapestried across high-beam walls, or piles of shoes in *The Republic of Unknown Territory*—that belong to no one, perhaps only phantoms of migrants crossing the water, searching for better lives, trying to outrun ghosts. In Udondian's work, there is a preoccupation with borders, colonial and imaginary lines that decide whether you can get a tourist visa in Nigeria to attend a graduation ceremony in New York City or be able to participate in the Venice Biennial.

When Udondian could not attend the 2015 Venice Biennial, she staged her own version of the biennial as her master's thesis. When Trump came to power in 2016 and a strong wave of xenophobia blew across America, she created a fake embassy in Provincetown for an unknown territory. In order to gain access to the art exhibit, visitors needed to fill out forms and undergo an interview, which was both intrusive and unpredictable, reflecting the absurdity of the visa process itself. There was outrage when patrons—US citizens who were not accustomed to hearing "no"—were barred entry. *Do you know who I am? Do you know the order of things? Why are you asking how much money I make? Why are you asking about my sexual orientation?* The patrons who were allowed in smuggled out alcohol and food despite injunctions not to do so. A few tried alternative methods to break into the gallery, which had turned into a border between two nations. If you are not a citizen of someplace, can you exist? Are you nobody?

It's a question that grounds her latest exhibition in Smack Mellon, *How Can I Be Nobody*. The exhibition itself becomes a kind of archive about migration and its costs. In creating a tapestry of second-hand clothing that hangs with galactic proportions, she enlisted the help of immigrant women from Buffalo. We see the work of their hands, but we also hear their voices, testimonials of their own journeys. The conversation feels somewhat ghostly. Behind their stories, like the wooden ribs of the boat Udondian has created, we can hear everyone who has not survived. The work is an archive full of silences.

The past is ever-present in Udondian's work. Out of second-hand clothing, Udondian creates Victorian costumes, fashioning a new narrative of colonial history. Intrinsic to this work are ideas of economics and labor, signaling our current neocolonial landscape. Who bears the cost of production? What is the value of a life? Udondian does not give us images of individuals, of migrants, but anonymous pieces and objects—molds of hands, dangling headscarves—as if asking us to imagine more deeply, into the space of the unknown, the magnitude of everyone and everything that has been lost.

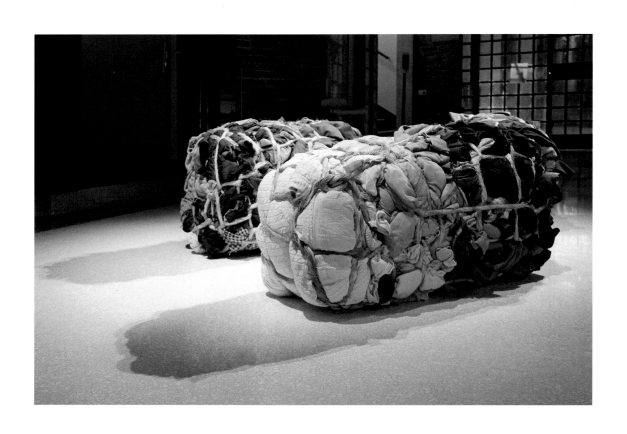

Okrika Bale, 2011
Used clothes, repurposed shipping rope
Dimensions variable
Image credit: Roberto Moro

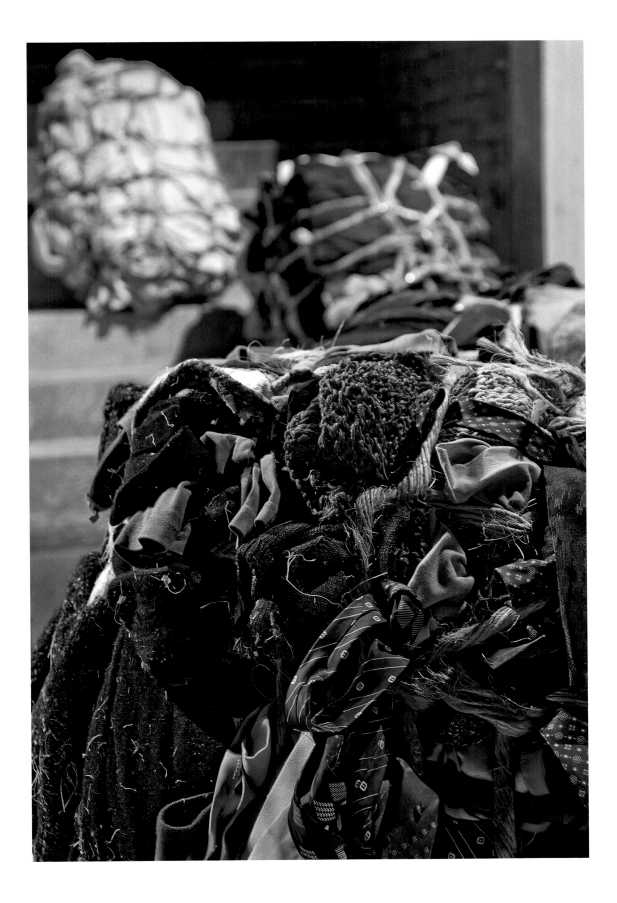

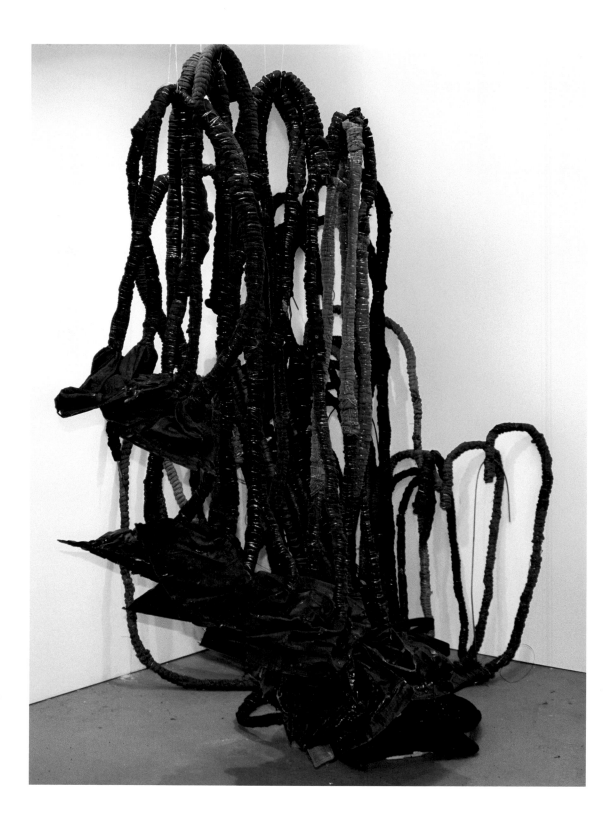

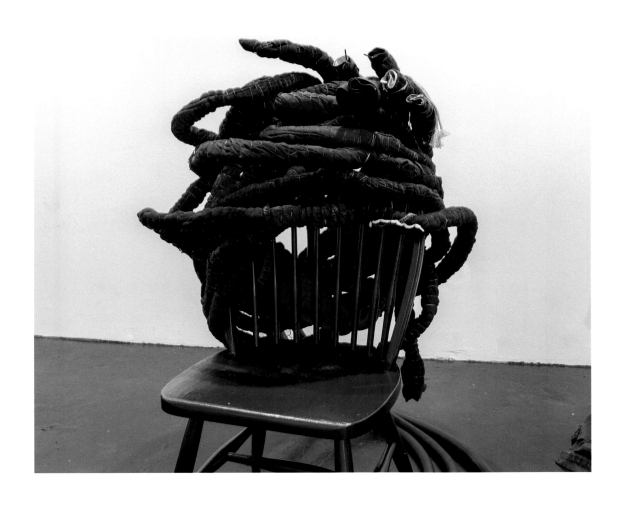

Onile-gogoro (detail), 2015
Repurposed clothes, fabrics, wire, metal rods, resin
Dimensions variable

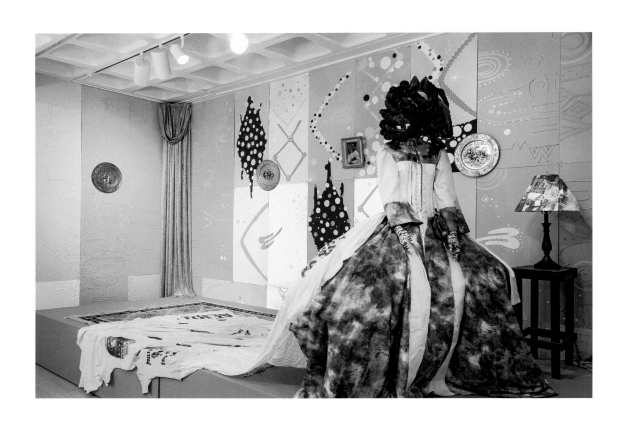

Oba-hyphenated 1 & 2 (installation), 2017
Fabricated costume with repurposed materials, second-hand textiles,
board, wire, acrylic, used lamp and table, mannequin, wood, screen print
Dimensions variable
Image credit right page: Naya Bricher

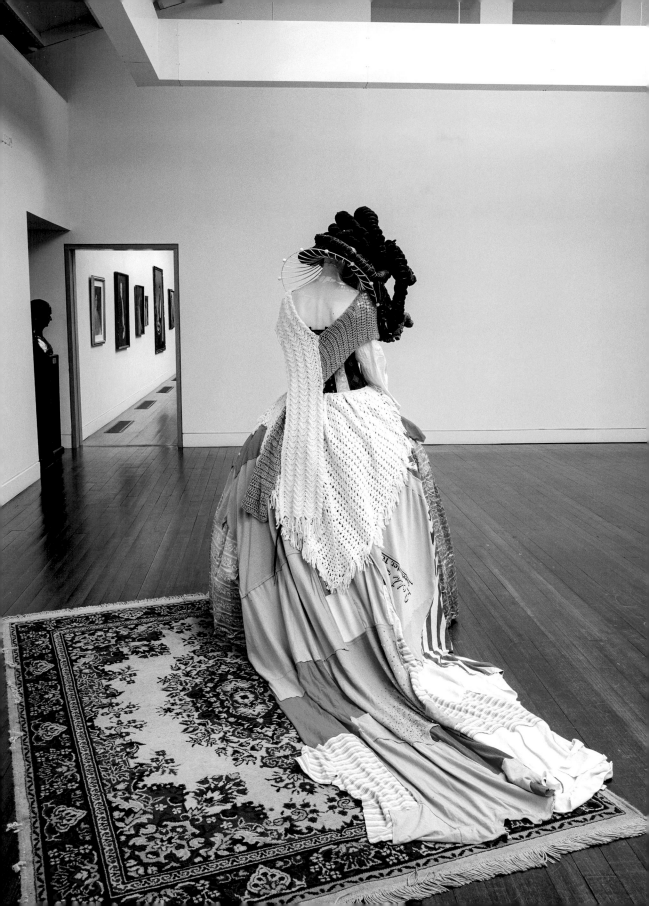

Green Badagry, 2012
Outdoor installation
Second-hand clothes, thread
Dimensions variable
Image credit: Novo Isioro

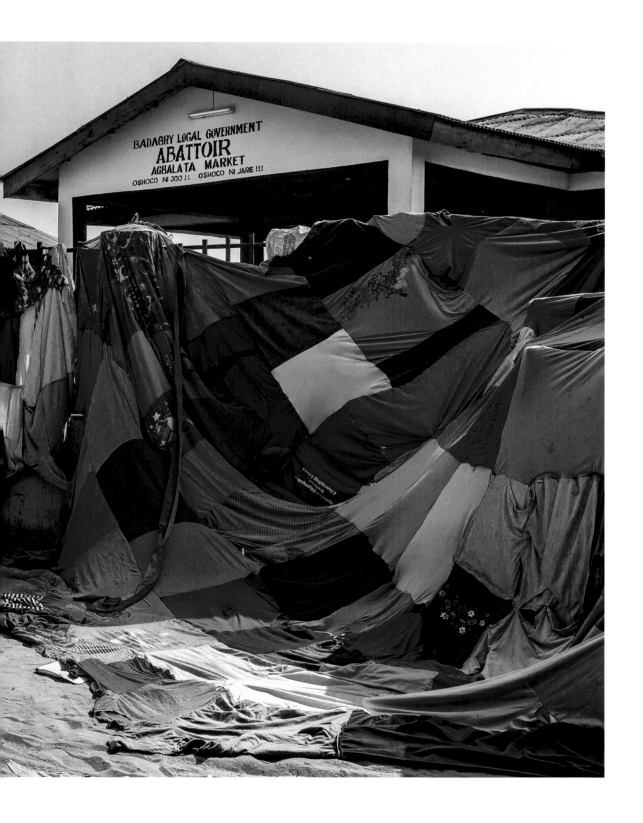

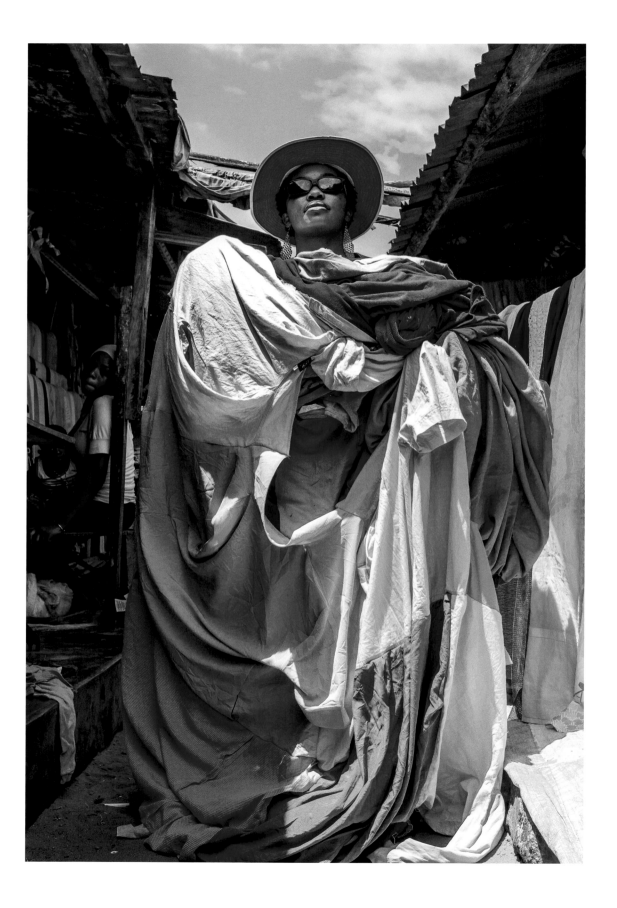

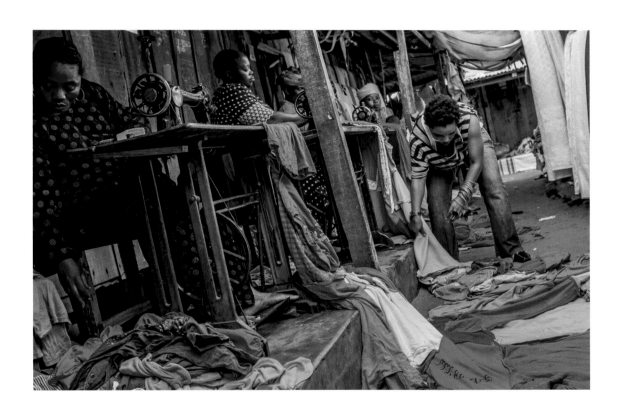

Green Badagry: Portrait of the Artist, 2012
Outdoor installation
Second-hand clothes
Dimensions variable
Image credit: Novo Isioro

Green Badagry Seamstresses
Image credit: Novo Isioro

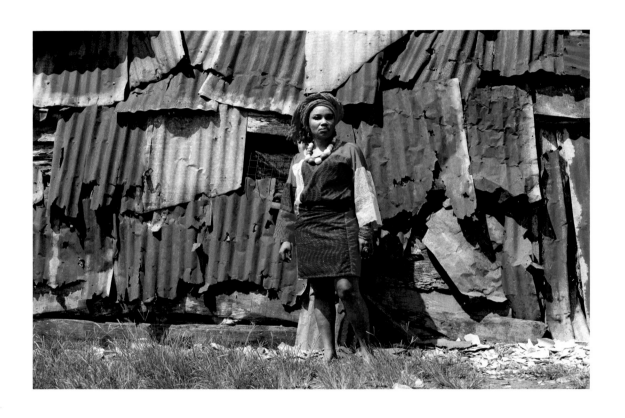

Ndise Mmi (self-portrait), 2013
Series of 8 images; C-print on Dibond
24 × 36 in.

Ndise Mmi (self-portrait), 2013
Series of 8 images; C-print on Dibond
36 × 24 in.

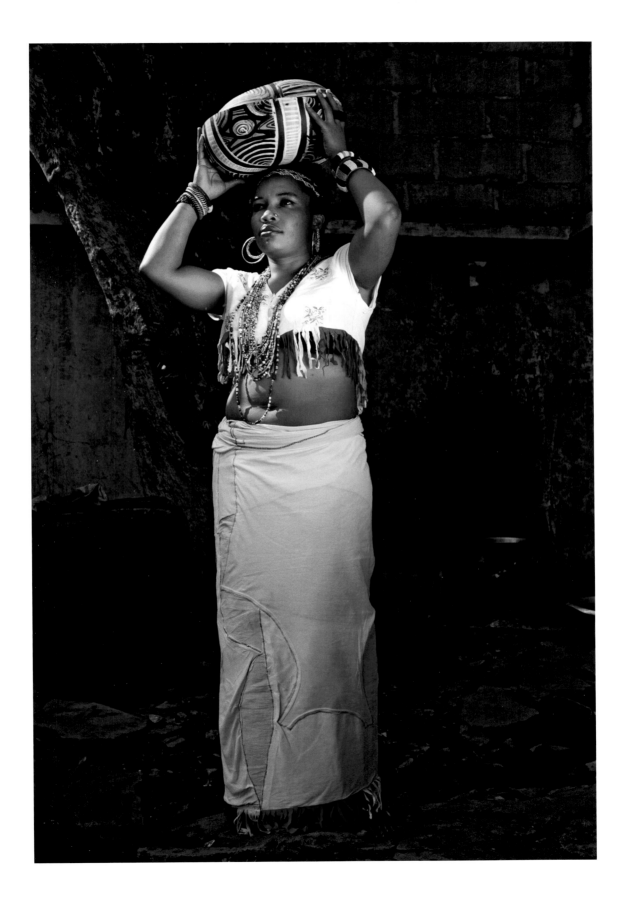

Ndise Mmi (self-portrait), 2013
Series of 8 images; C-print on Dibond
24 × 36 in.

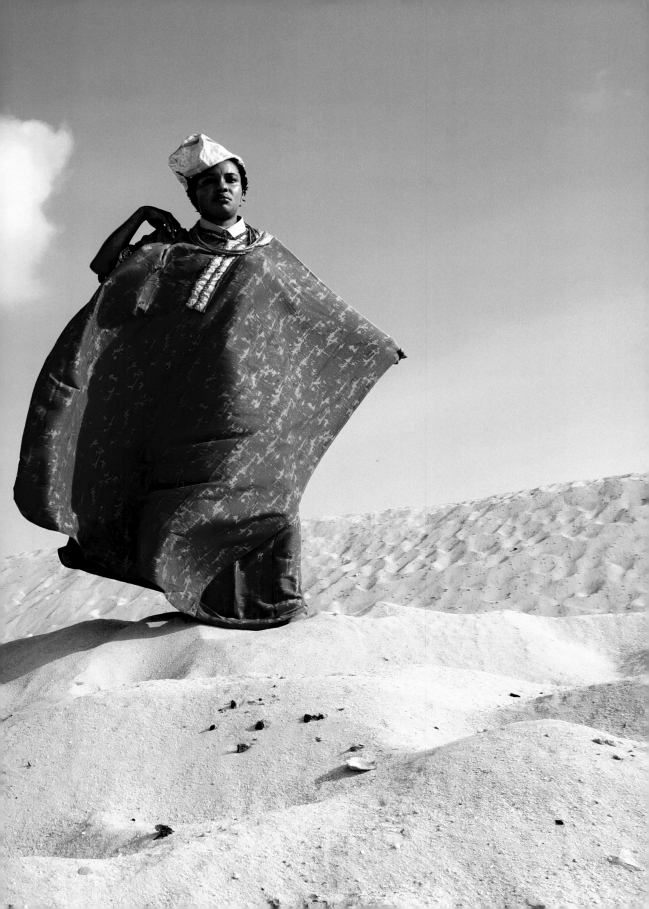

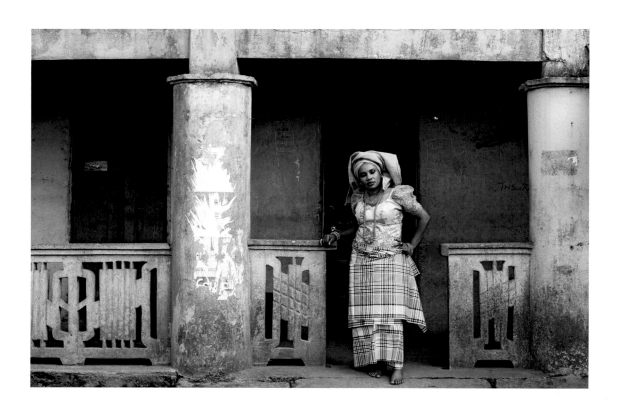

Ndise Mmi (self-portrait), 2013
Series of 8 images; C-print on Dibond
24 × 36 in.

Ndise Mmi (self-portrait), 2013
Series of 8 images; C-print on Dibond
36 × 24 in.

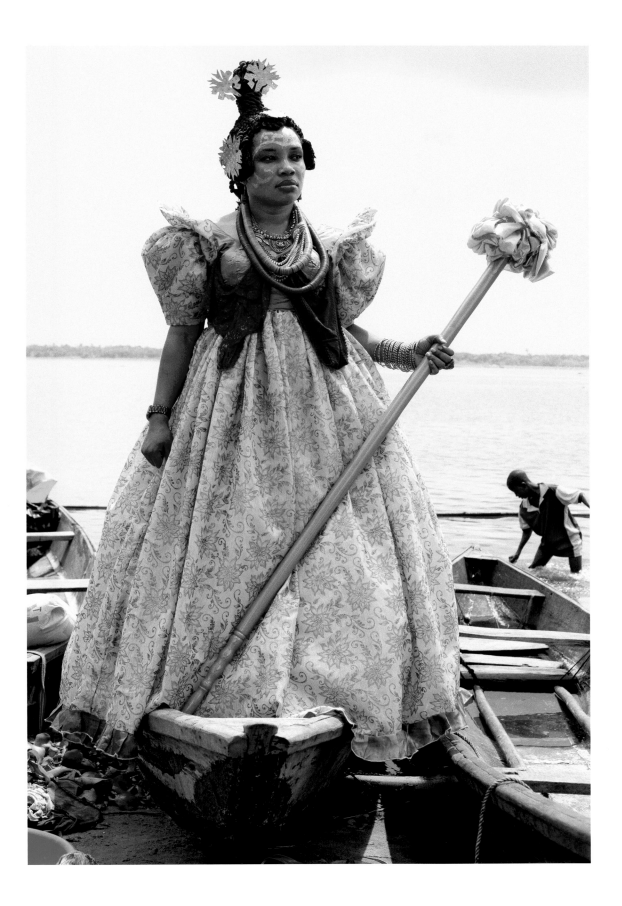

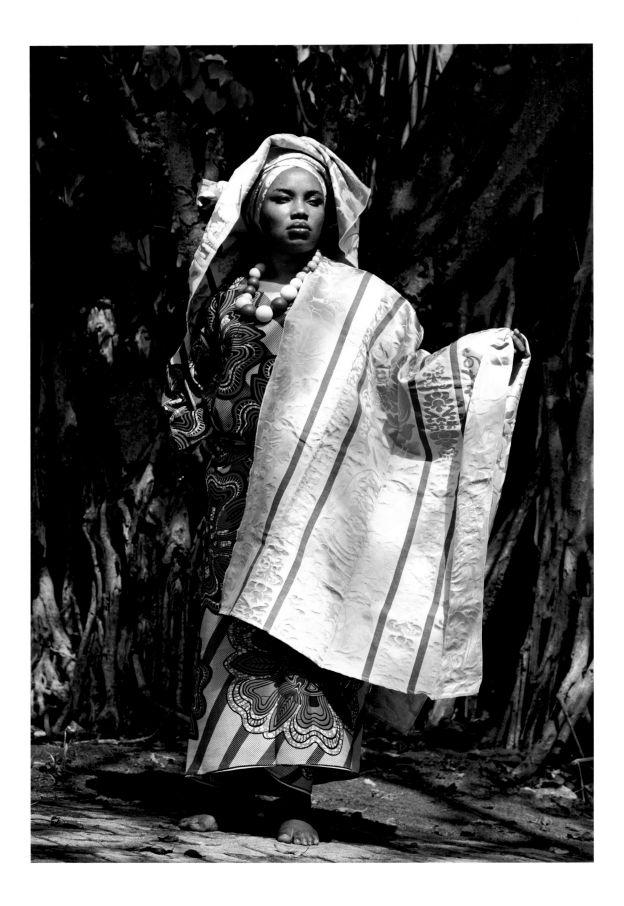

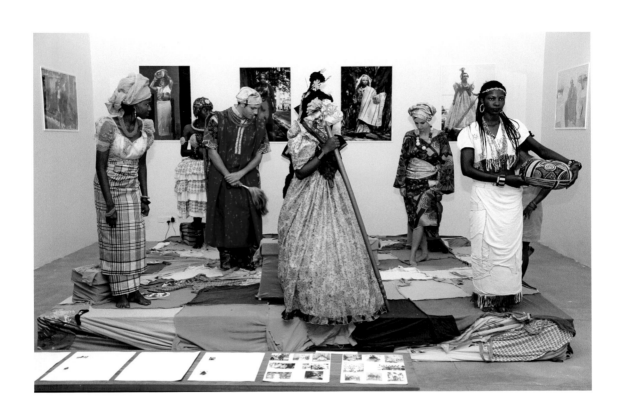

Ndise Mmi (self-portrait), 2013
Series of 8 images; C-print on Dibond
36 × 24 in.

Fog of Colours, 2013
Mixed fabrics, wood, second-hand clothing, life sculptures,
archival photos and text
Dimensions variable

The Republic of Unknown Territory, 2017
Performance and multimedia installation
Dimensions variable

The Republic of Unknown Territory, 2017
Performance and multimedia installation
Dimensions variable

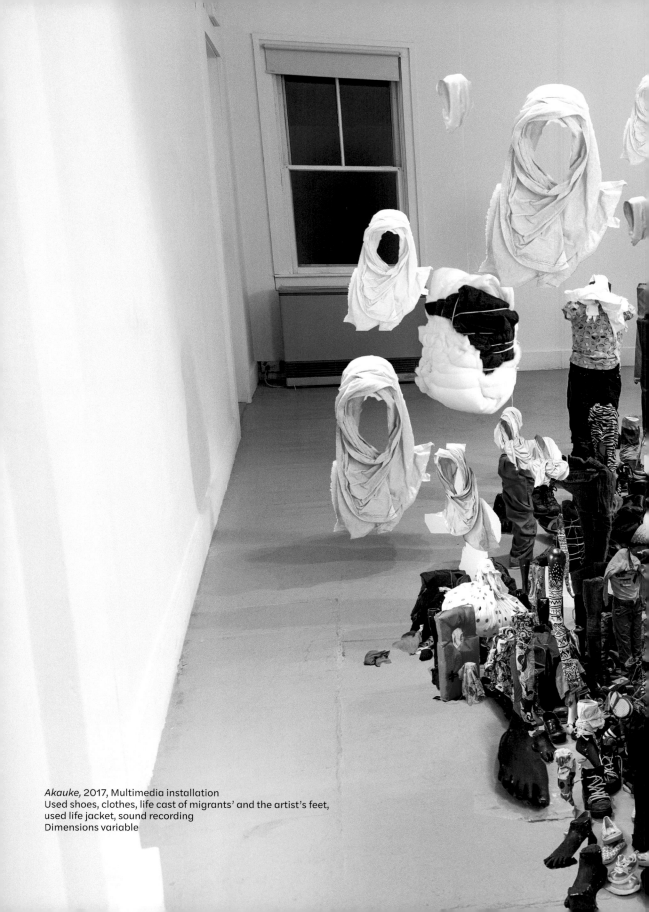

Akauke, 2017, Multimedia installation
Used shoes, clothes, life cast of migrants' and the artist's feet,
used life jacket, sound recording
Dimensions variable

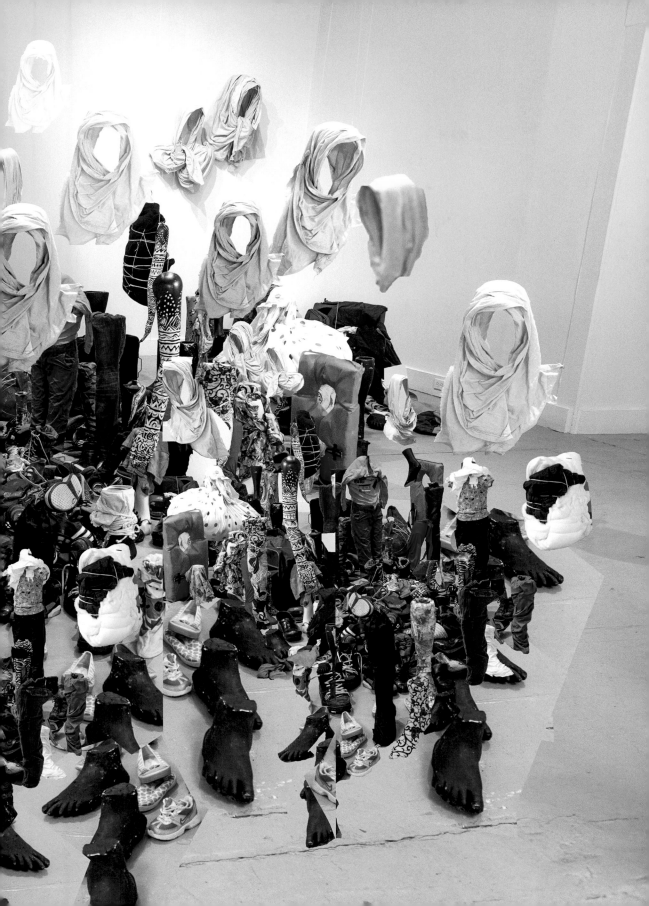

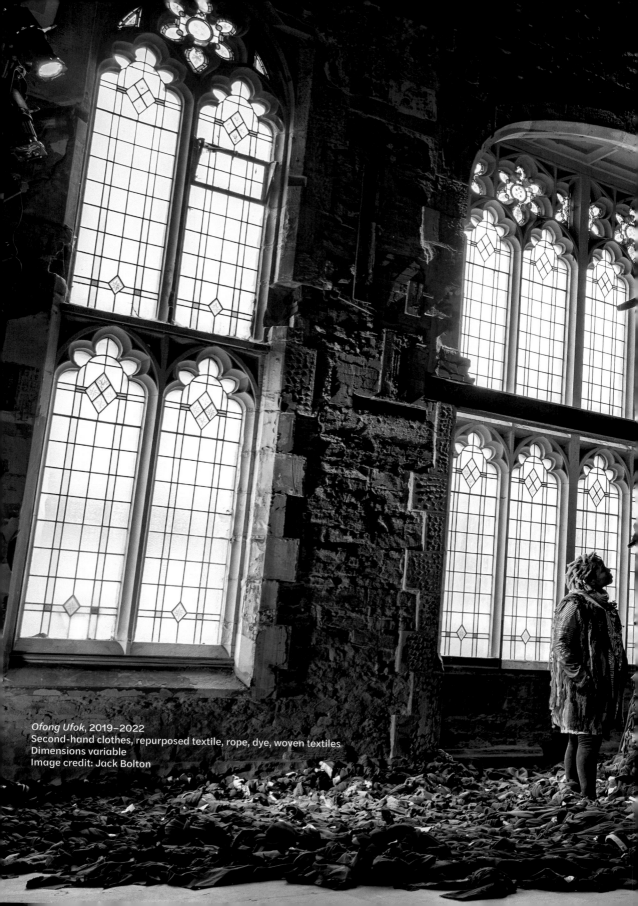

Ofong Ufok, 2019–2022
Second-hand clothes, repurposed textile, rope, dye, woven textiles
Dimensions variable
Image credit: Jack Bolton

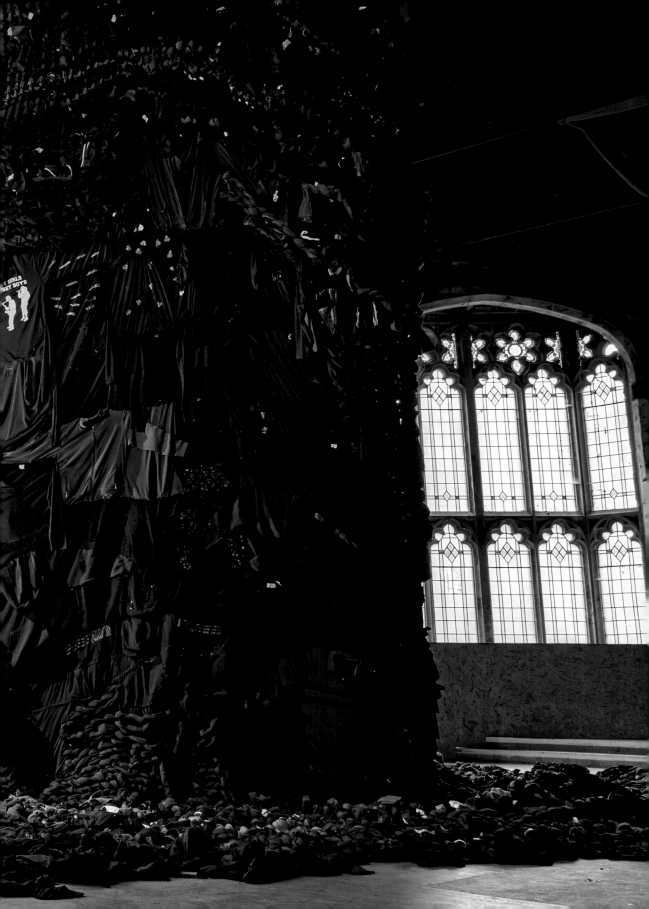

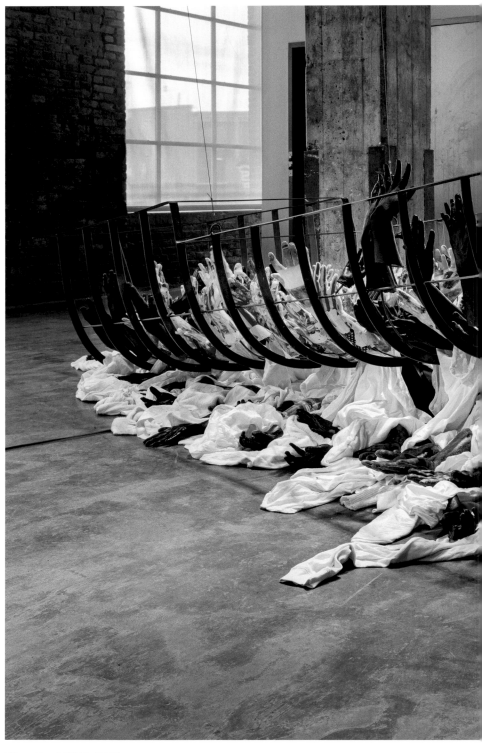

Ubom Keed, 2020–2022
Metal, life-cast hands, used clothes, flags of various countries
Dimensions variable
Image credit: Etienne Frossard

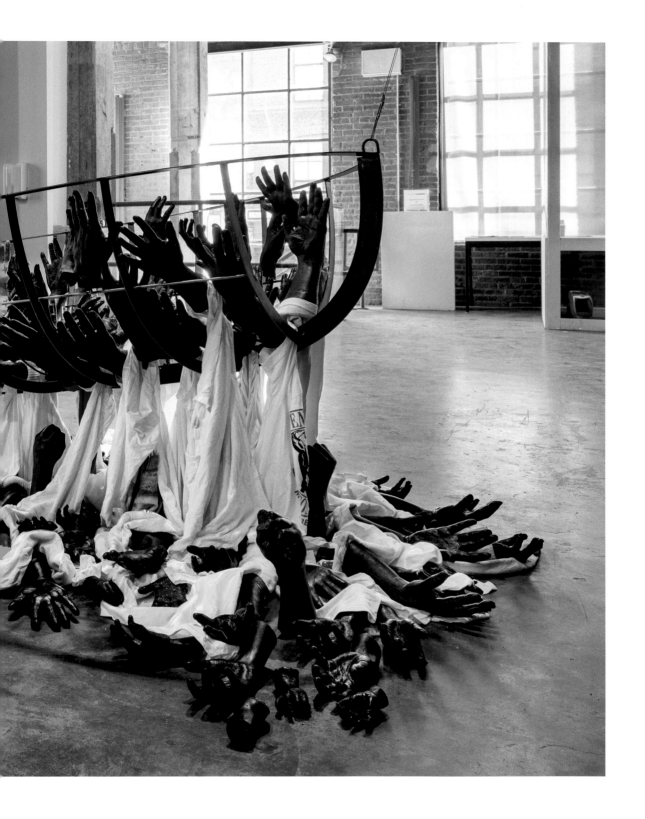

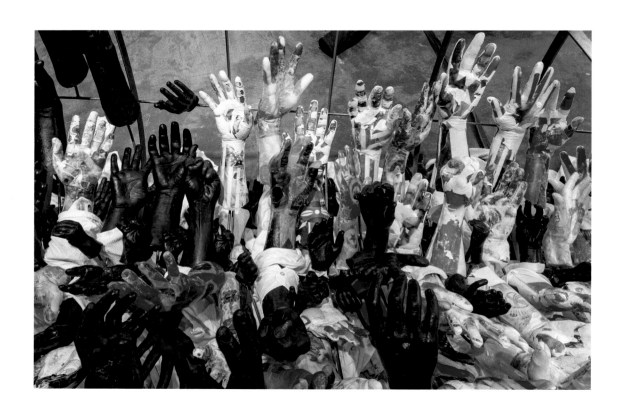

Ubom Keed, 2020–2022
Metal, life-cast hands, used clothes, flags of various countries
Dimensions variable
Image credit: Etienne Frossard

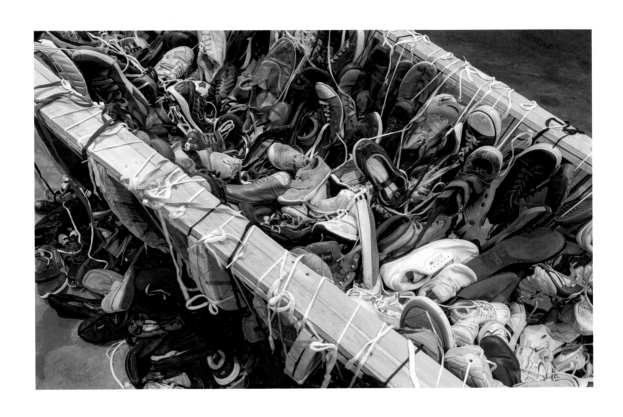

Ubom Iba, 2021
Metal, salvaged shipping pallets, used shoes, shoelaces
Dimensions variable
Image credit: Etienne Frossard

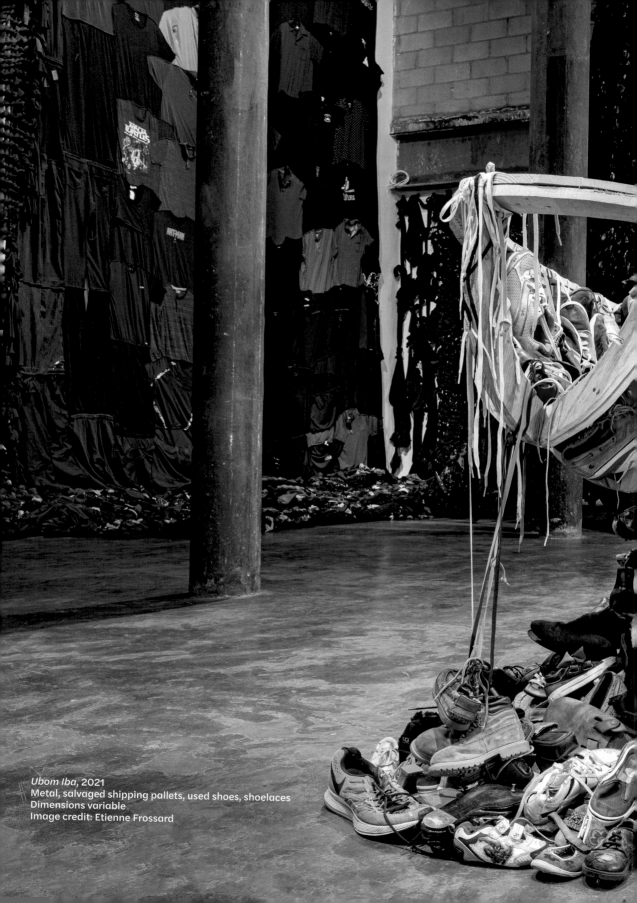

Ubom Iba, 2021
Metal, salvaged shipping pallets, used shoes, shoelaces
Dimensions variable
Image credit: Etienne Frossard

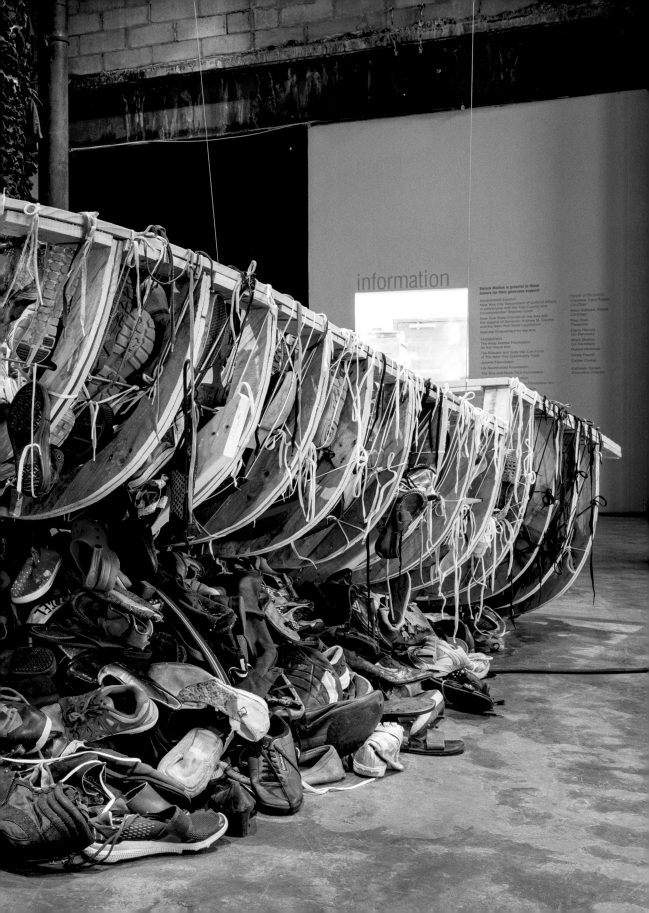

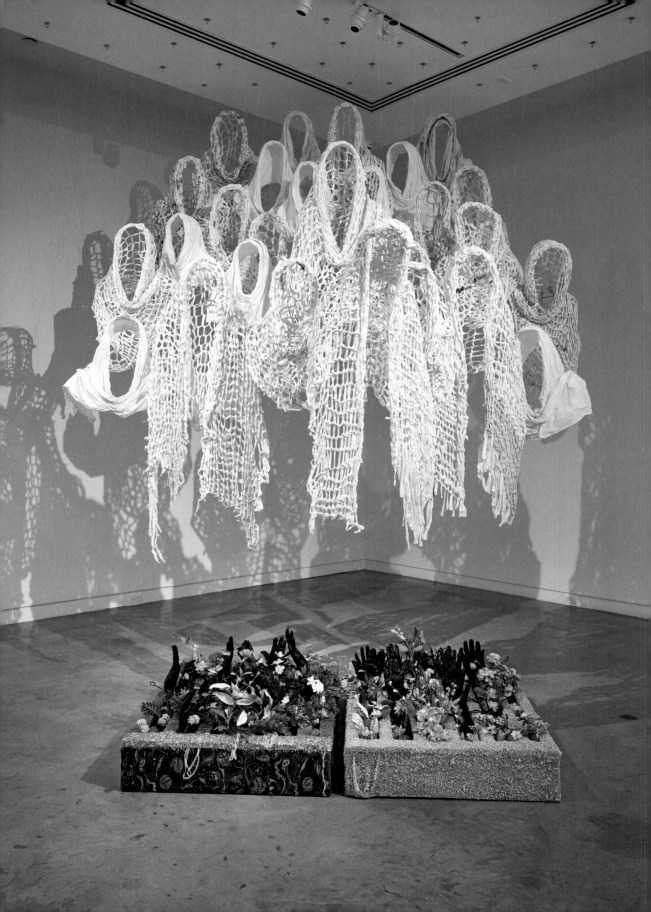

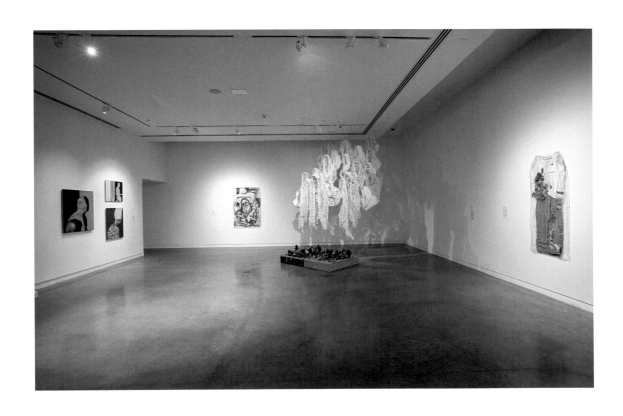

Akaisang ye Beyond Cages; 1277, 1245, 2019–2022
Life-cast hands, Paverpol, wood, repurposed jewelry,
beads, flowers, fabric, resin
Dimensions variable
Image credit: Argenis Apolinario

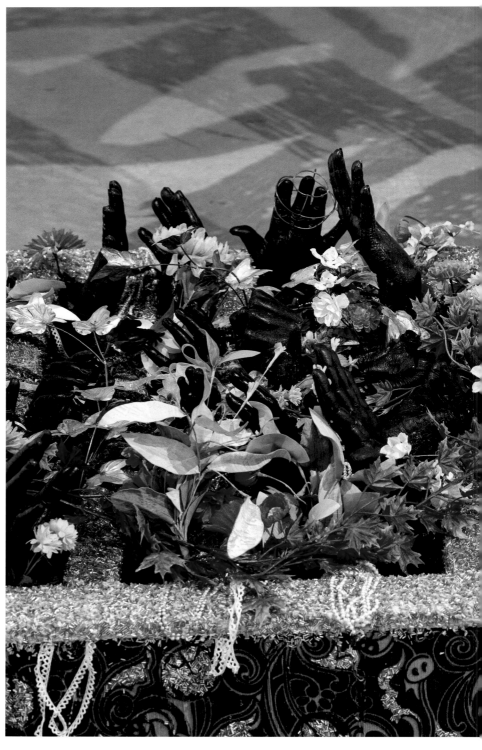

Beyond Cages 1277, 1245 (detail), 2020–2021
Wood, life-cast hands, repurposed jewelry, beads, flowers, fabric, resin
36 × 42 in. (2)
Image credit: Argenis Apolinario

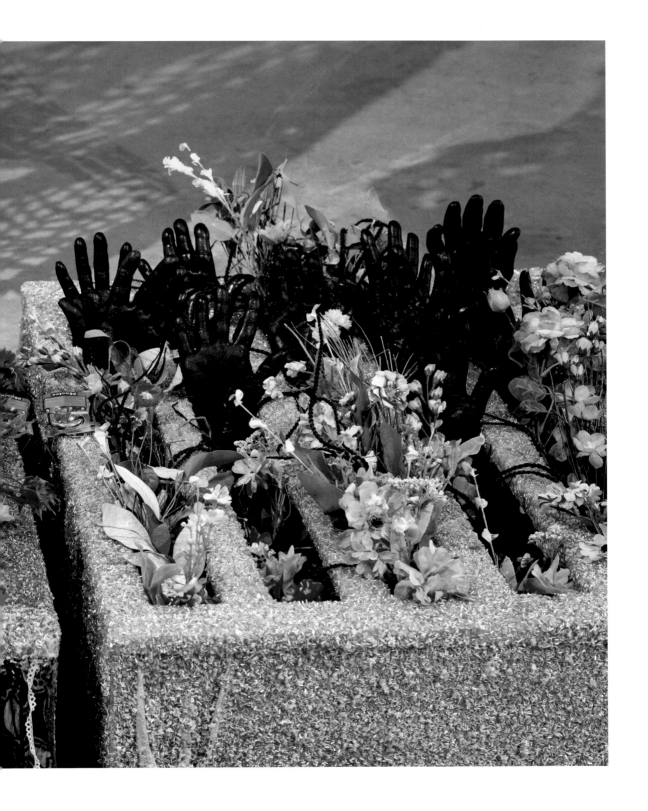

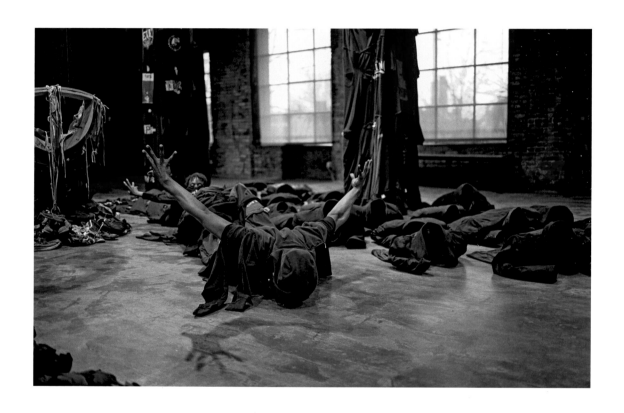

Nsinam mi Ke Ndi Owo, 2023
Performance
Dimensions variable

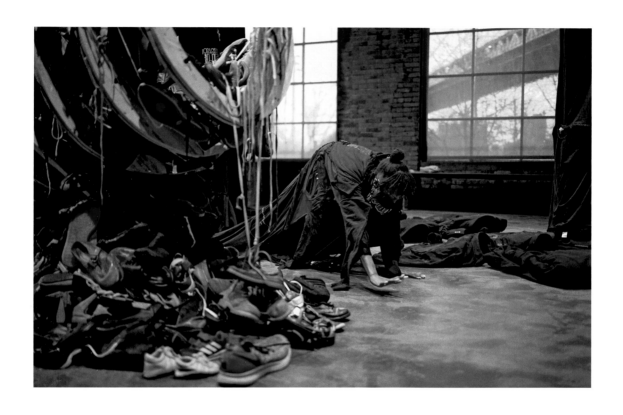

Nsinam mi Ke Ndi Owo, 2023
Performance
Dimensions variable

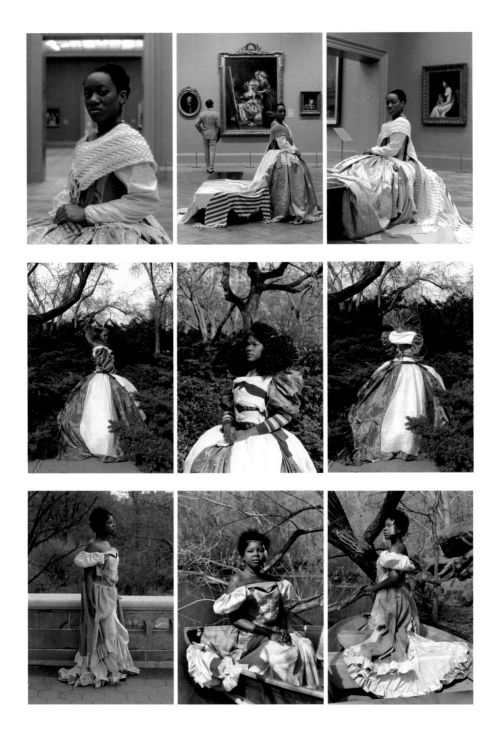

The Obas, 2016
Photography / performance; series of 8 triptychs
64 × 40 in. each × 3 images (triptych)

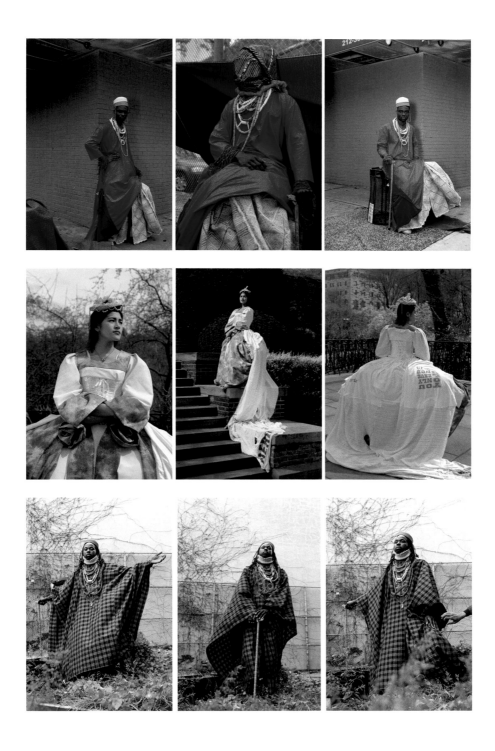

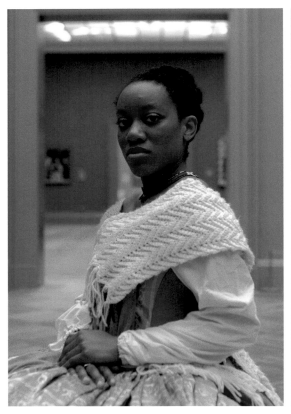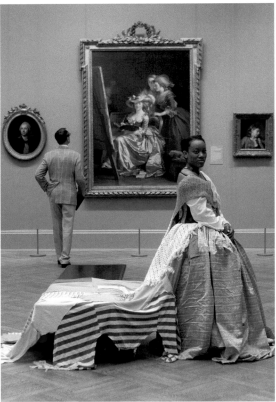

The Obas: Her Majesty Queen Olori Omoyemi Ade, 2016
Photography / performance; series of 8 triptychs
64 × 40 in. each × 3 images (triptych)

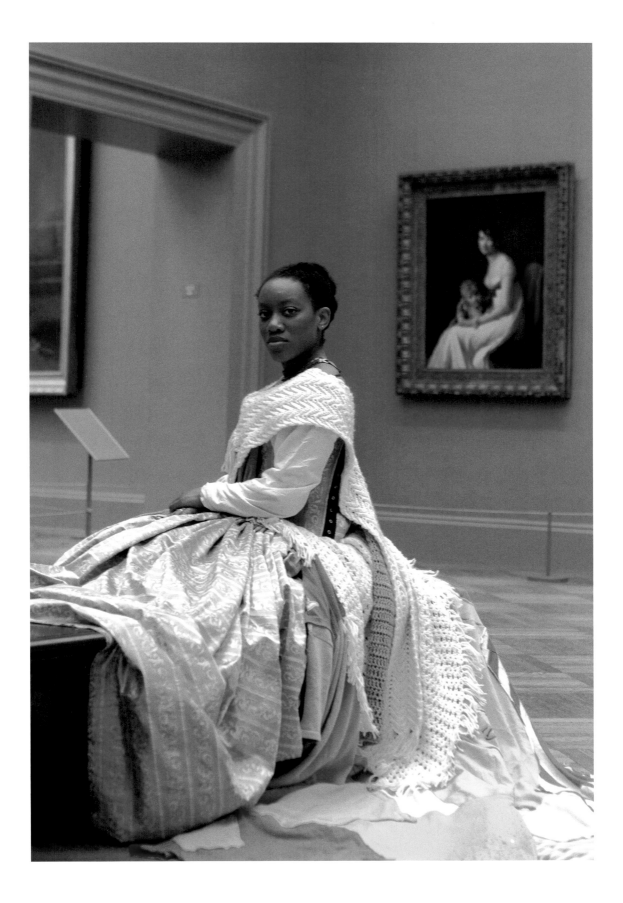

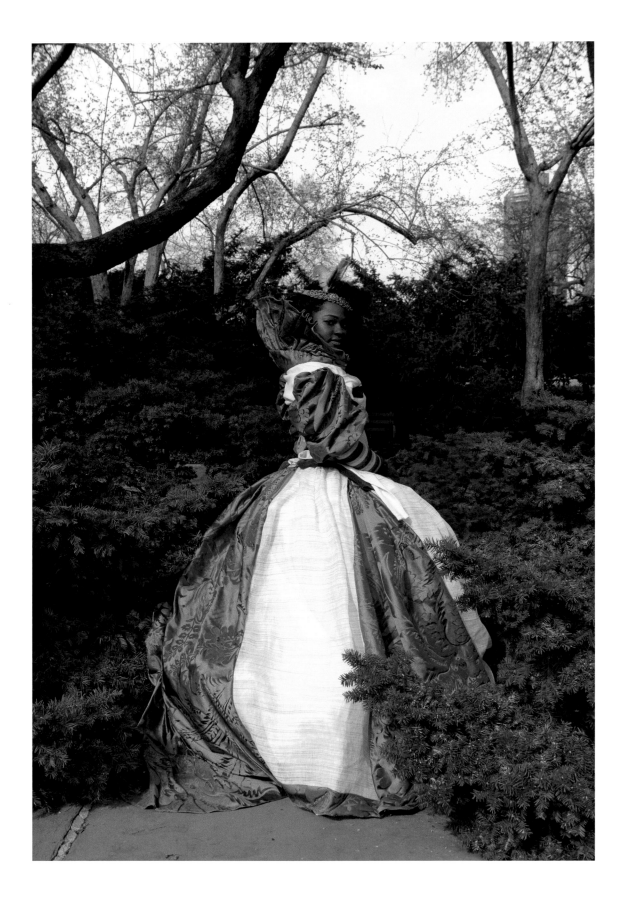

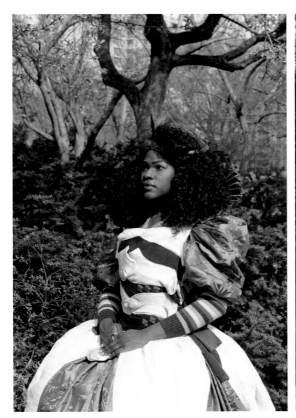
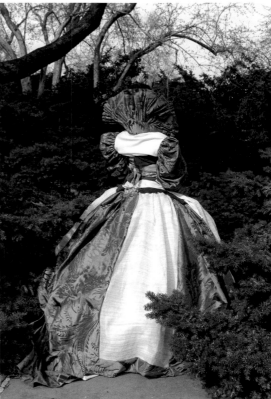

The Obas: Her Majesty Queen Ada Charlotte Osumuo, 2016
Photography / performance; series of 8 triptychs
64 × 40 in. each × 3 images (triptych)

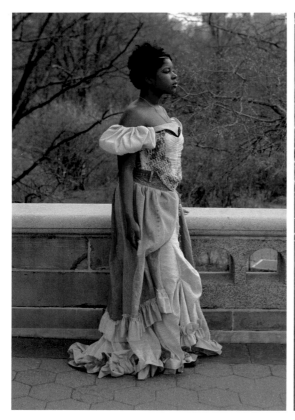
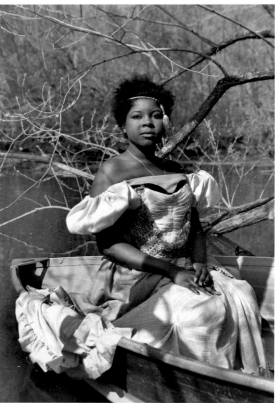

The Obas: Her Royal Highness Queen Sara Matsuda, 2016
Photography / performance; series of 8 triptychs
64 × 40 in. each × 3 images (triptych)

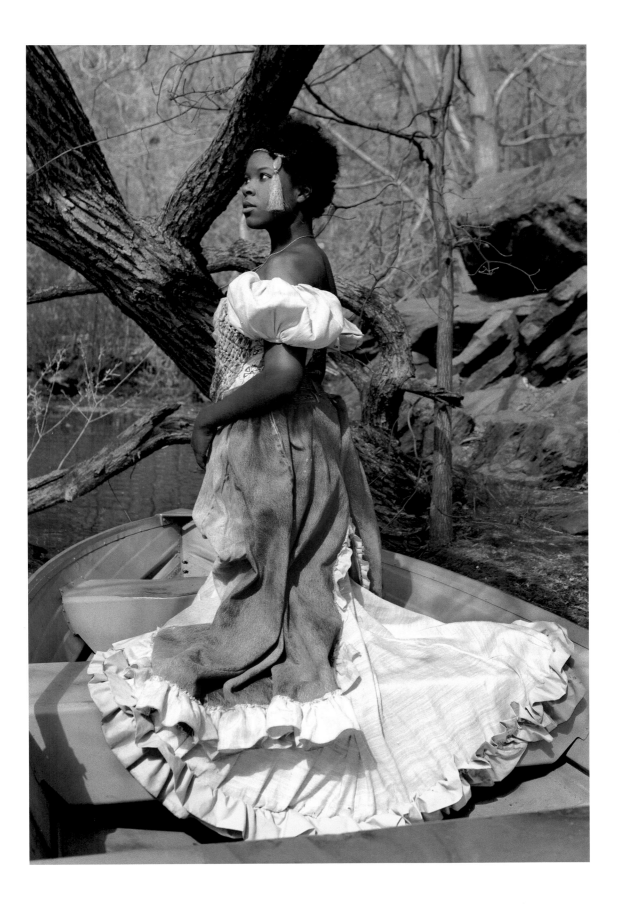

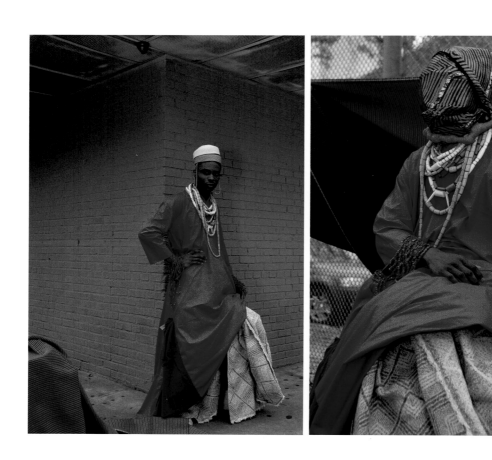

The Obas: His Imperial Majesty Tim Alfred Oshodi, Agbogidi Obi of Onicha, 2016
Photography / performance; series of 8 triptychs
64 × 40 in. each × 3 images (triptych)

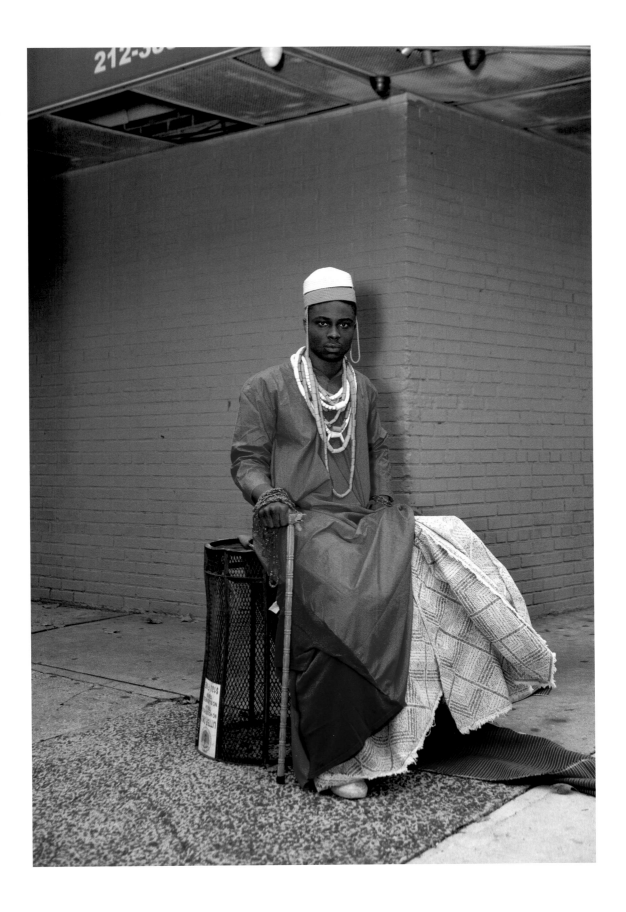

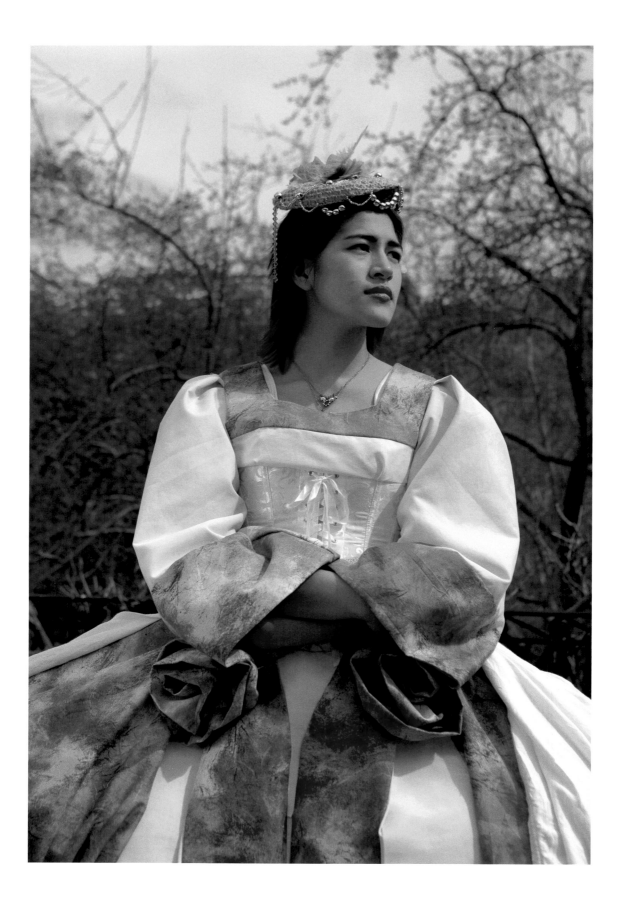

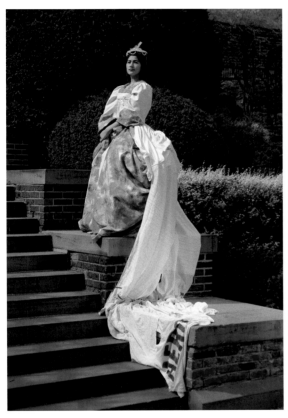 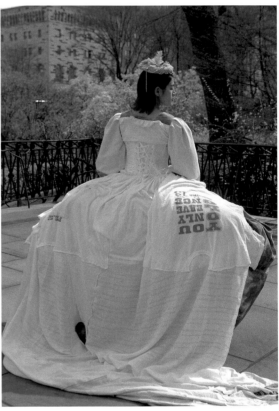

The Obas: Her Royal Majesty Queen Emma Sulkowicz, 2016
Photography / performance; series of 8 triptychs
64 × 40 in. each × 3 images (triptych)

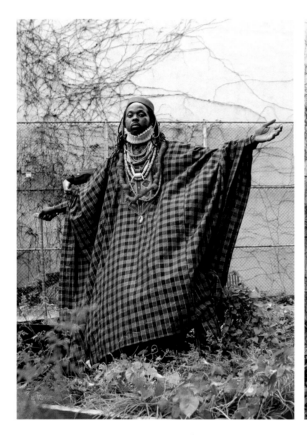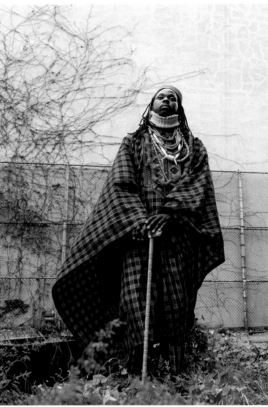

The Obas: His Imperial Majesty Oba Samuel Challenger, Olubuse III, the Ooni of Ife, 2016
Photography / performance; series of 8 triptychs
64 × 40 in. each × 3 images (triptych)

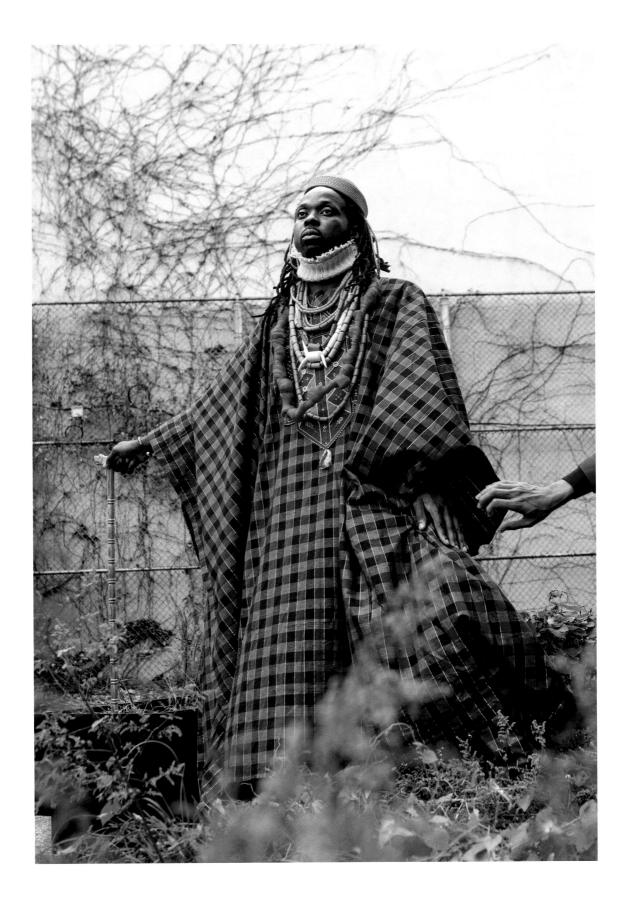

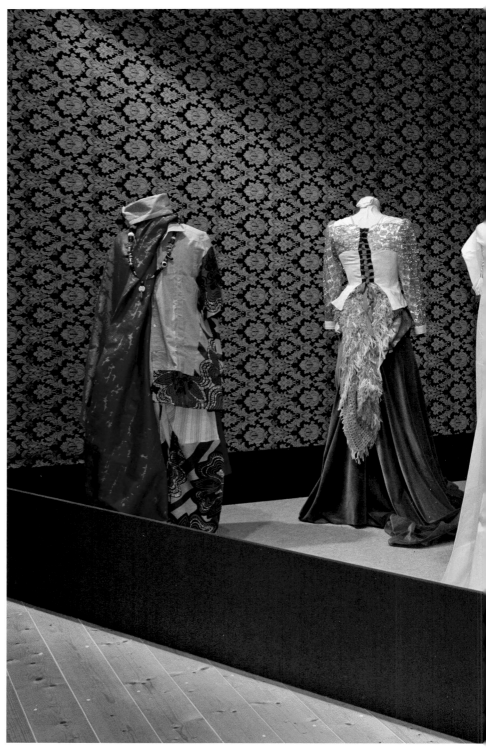

Second-hand Museum, 2011
Fabricated costume from repurposed clothing, mannequin, second-hand pants,
clothes, mixed textiles, wallpaper, and wood
Dimensions variable

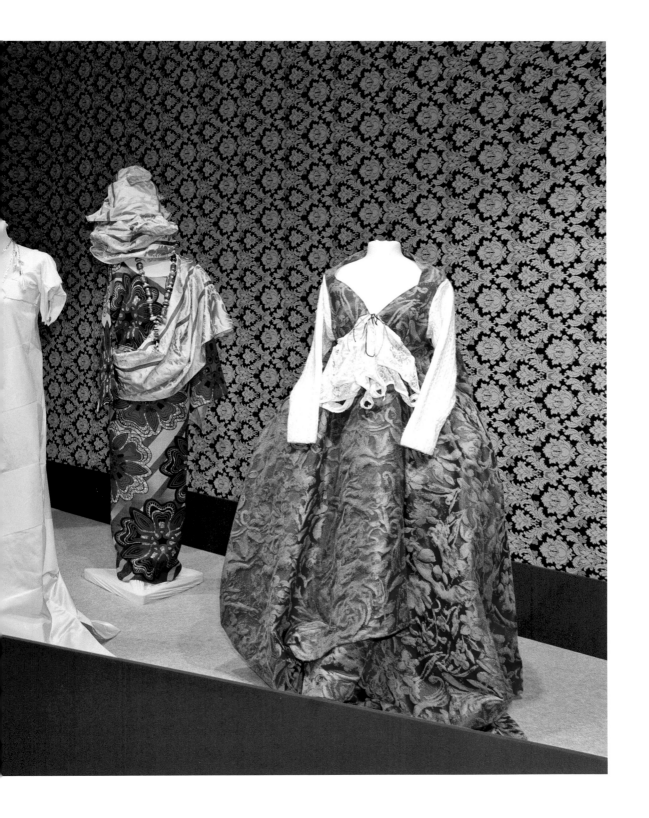

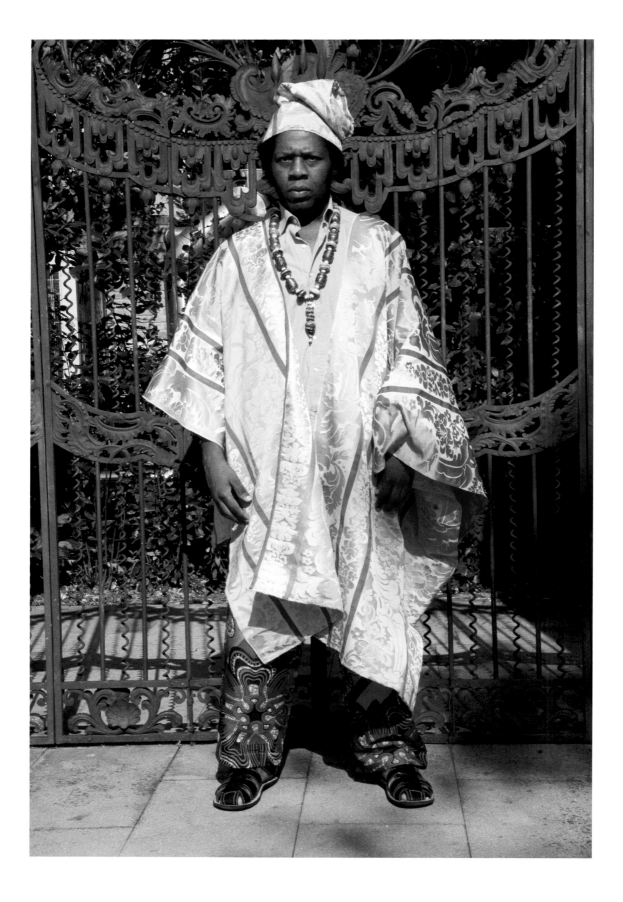

Venetian Portraits, 2011
Series of 4 images; inkjet print on Dibond
64 × 40 in.

Venetian Portraits, 2011
Series of 4 images; inkjet print on Dibond
64 × 40 in.

Venetian Portraits, 2011
Series of 4 images; inkjet print on Dibond
64 × 40 in.

Venetian Portraits, 2011
Series of 4 images; inkjet print on Dibond
64 × 40 in.

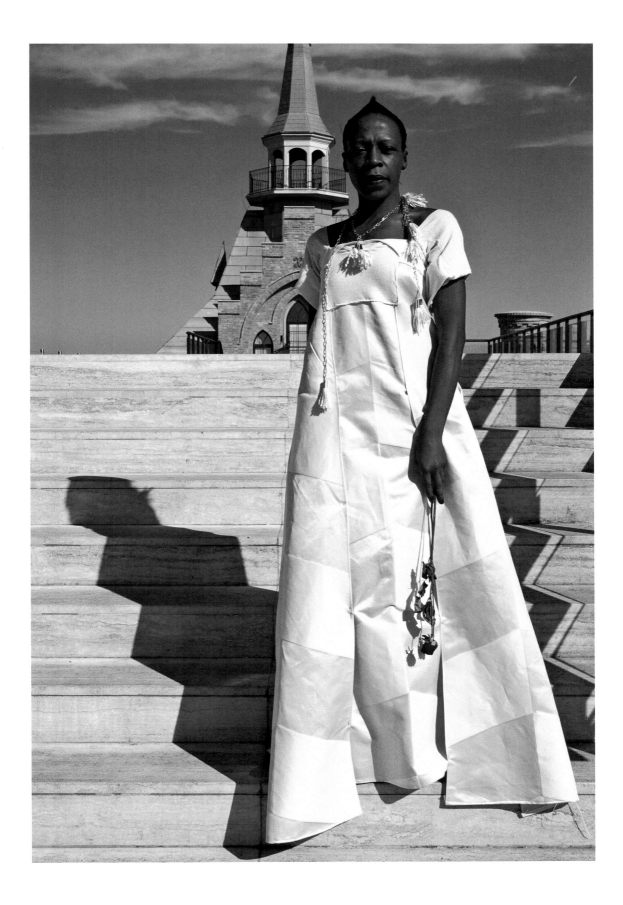

1244, 1245, 1246, 1247 (quadriptych), 2018
Repurposed laces, screen print, life-cast hands, hair on canvas
30 × 24 in. each

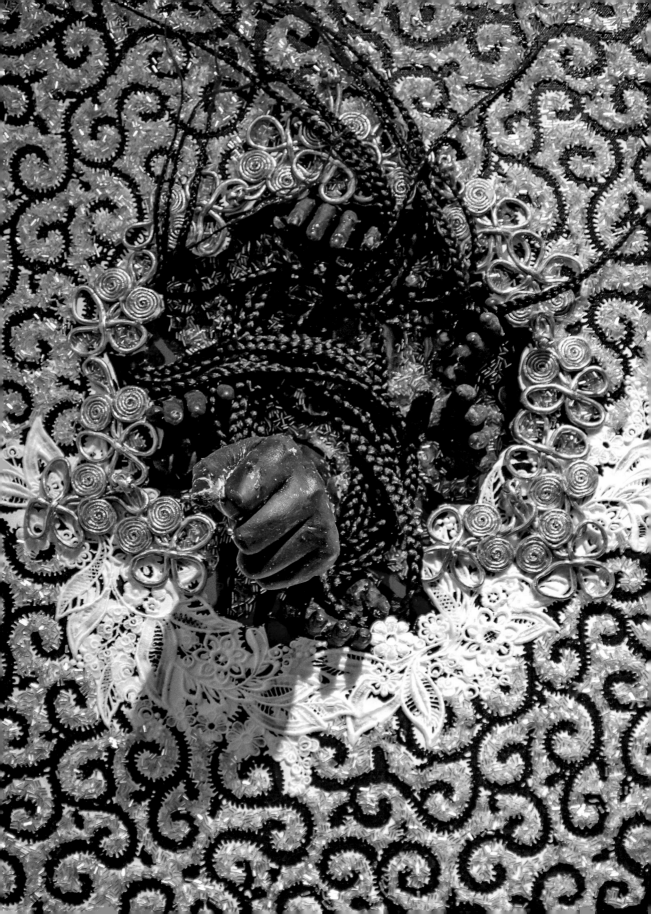

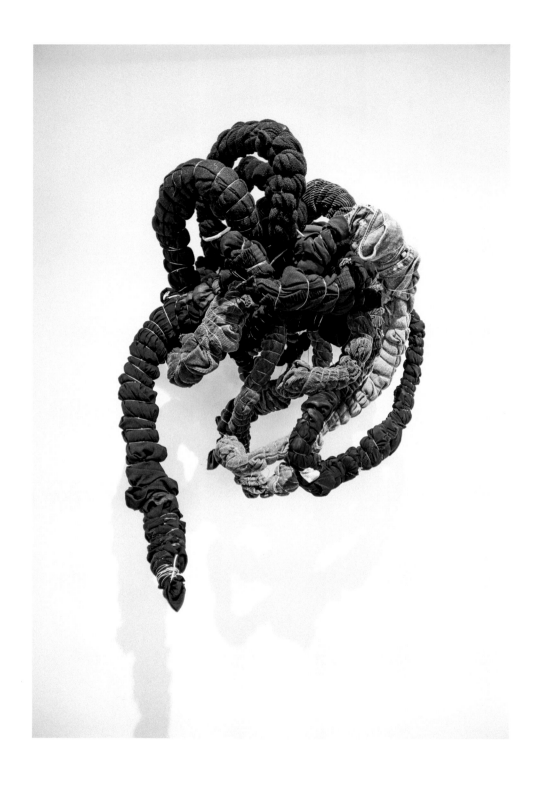

Oba's Headdresses, 2016
Repurposed clothing, found metal, wire, rod, beads,
buttons, mannequin bust
36 × 24 in. each

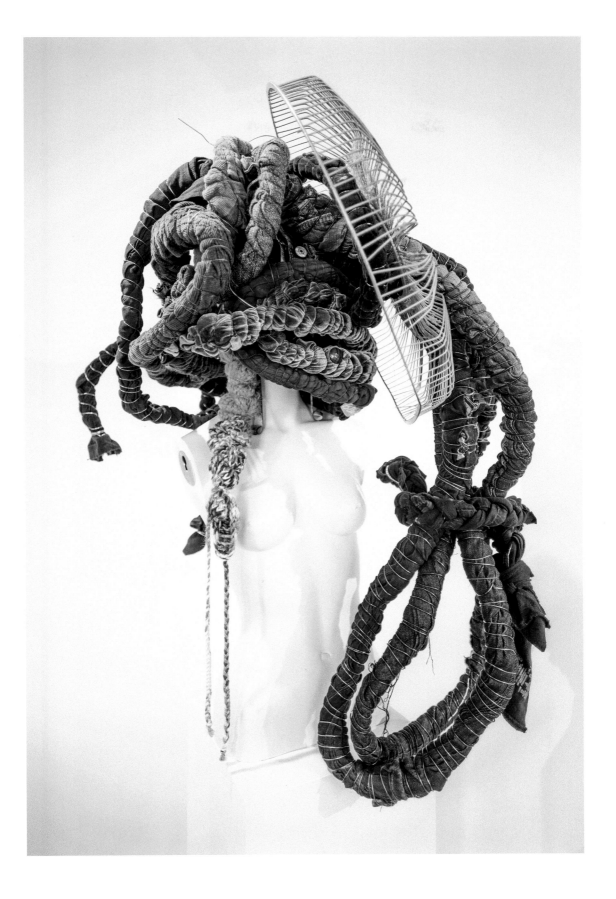

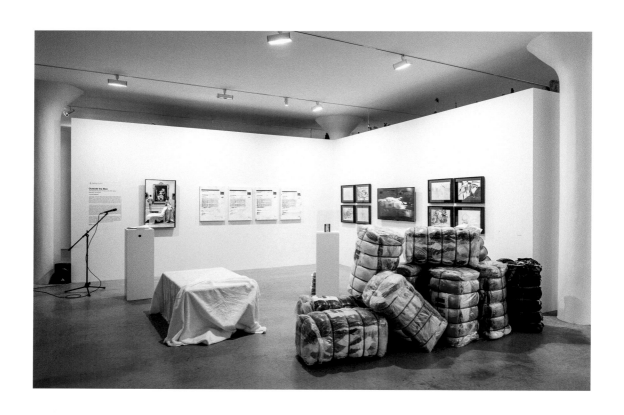

Outside the Box: The Inaugural Nigerian Pavilion at the 56th Venice Biennale, 2015–2016
Multimedia installation / performance
Dimensions variable
Image credit: Cary Whittier

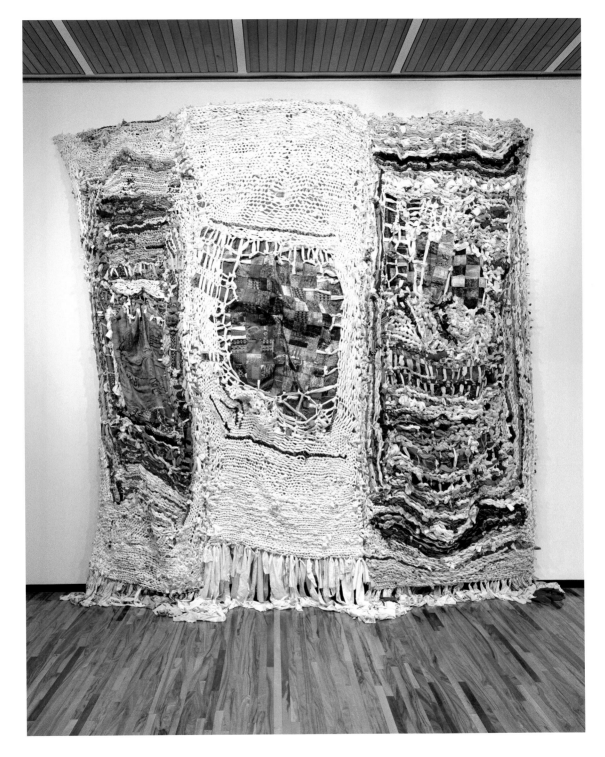

Aso Ikele (1948), 2011
Used clothes from Manchester, printed fabric, used burlap from Nigeria
296 × 280 in.
Image credit: Michael Pollard

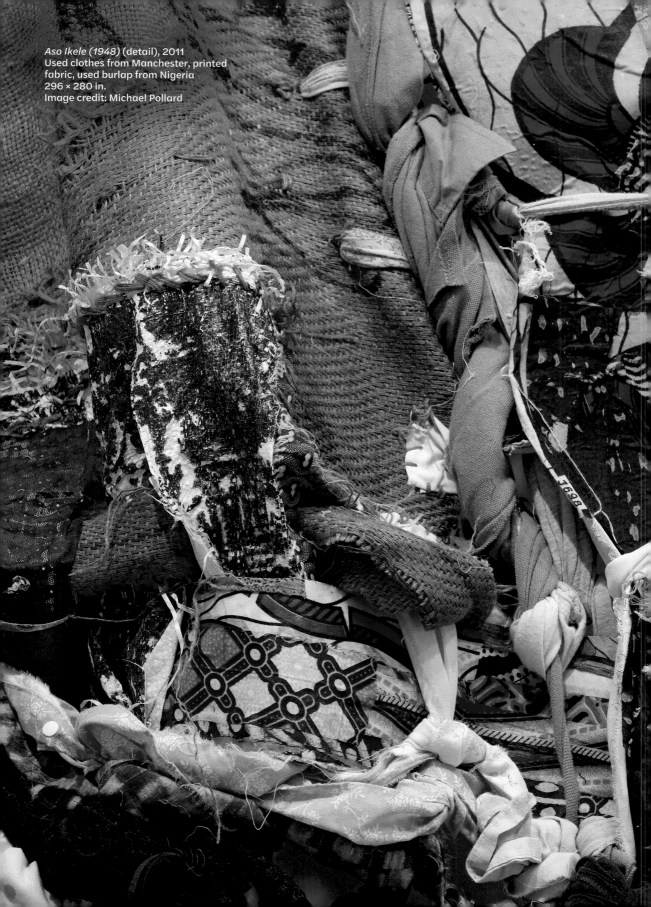

Aso Ikele (1948) (detail), 2011
Used clothes from Manchester, printed
fabric, used burlap from Nigeria
296 × 280 in.
Image credit: Michael Pollard

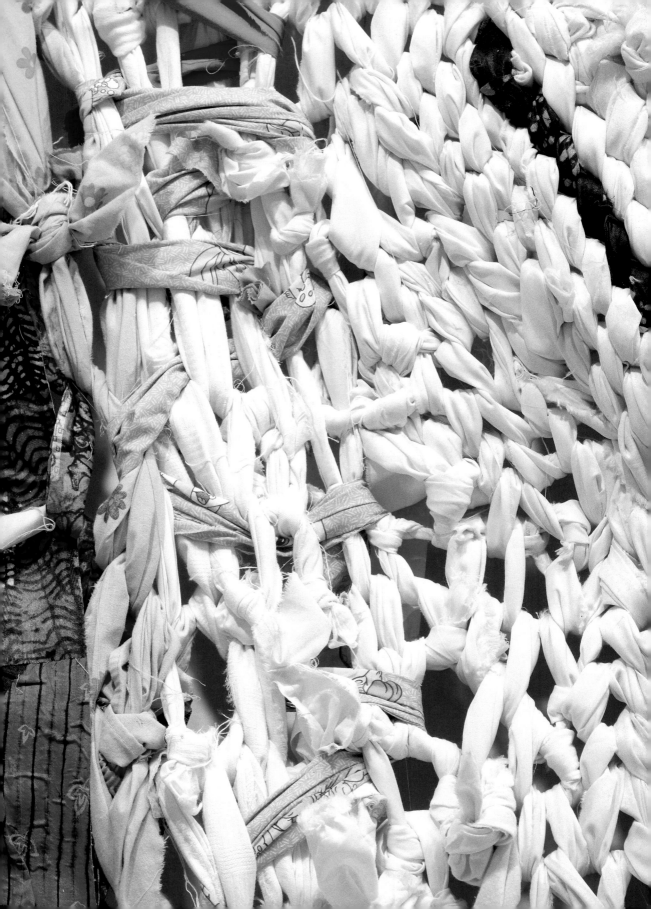

Evening Gown 1803, 2011
Bodice made from wool baby undergarments,
1980s jacket buttons, Rubelli fabric, jewel
with scraps of fabric and leather from a bag

Evening Gown, 1867, 2011
Skirt, Rubelli fabric, overskirt, fringed knit wool
poncho, printed silk skirt, bodice created by
repurposing a house frock

ABOUT THE AUTHORS

AYANNA DOZIER is a Brooklyn-based artist and writer who works in performance, experimental film, installation, printmaking, and analog photography. Her film work is in the permanent collection of the Whitney Museum of American Art and she is the author of *Janet Jackson's The Velvet Rope* (2020) for Bloomsbury Academic Press. She received her PhD in the Department of Art History and Communication Studies at McGill University and is an assistant professor of communication, with an emphasis in film, at the University of Massachusetts, Amherst. She is currently working on a manuscript on the life and art of Camille Billops.

AKIL KUMARASAMY is the author of the novel *Meet Us by the Roaring Sea* (FSG, 2022) and the linked story collection *Half Gods* (FSG, 2018), which was named a *New York Times* Editors' Choice, was awarded the Bard Fiction Prize and the Story Prize Spotlight Award and was a finalist for the PEN/Robert W. Bingham Prize. Her work has appeared in *Harper's Magazine*, *The Atlantic*, *American Short Fiction*, and *BOMB*, among others. She has received fellowships from the University of East Anglia, the Fine Arts Work Center in Provincetown, Yaddo, and the Schomburg Center for Research in Black Culture. She is an assistant professor in the Rutgers University-Newark MFA program.

SYLVESTER OKWUNODU OGBECHIE, professor of African art history at the University of California Santa Barbara, is an art historian, artist, and curator whose research focuses on African and African Diaspora arts, modern and contemporary art, and African cultural patrimony. Ogbechie is the author of *Ben Enwonwu: The Making of an African Modernist* (2008) and *Making History: African Collectors and the Canon of African Art Collection* (2011). He is the editor of *Artists of Nigeria* (2012) and the founder/editor of *Critical Interventions: Journal of African Art History and Visual Culture*. His awards include the Guggenheim Fellowship, Fellow/Consortium Professor of the Getty Research Institute, Daimler Fellow of the American Academy in Berlin, Senior Fellow of the Smithsonian Institution, Fellow of the Rockefeller Foundation, and Fellow of the Institute for International Education.

MOYO OKEDIJI, professor of African art history at the University of Texas at Austin, is an art historian, artist, and curator. He studied fine arts at the University of Ife before proceeding to the University of Benin, where he did an MFA in African art criticism, poetry, and painting. At the University of Wisconsin, Madison, he received a PhD in African arts and Diaspora visual cultures. Okediji was the curator of African and Oceanic arts at the Denver Art Museum and has taught at various colleges in the United States, including Wellesley College, Gettysburg College, the University of Wisconsin, Madison, and the University of Colorado at Denver. He has also exhibited at various places, including the New Museum of Contemporary Art, New York; the Smithsonian Institution, Washington, DC; and the National Museum Gallery, Lagos, Nigeria. He is the author of books and exhibition catalogues including *African Renaissance: Old Forms, New Images in Yoruba Art* and *The Shattered Gourd: Yoruba Forms in Twentieth-Century American Art.*

RACHEL VERA STEINBERG is the curator and director of exhibitions at Smack Mellon in Brooklyn, New York, where she oversees the production of ambitiously scaled installations and exhibitions. Her work explores cultural mythmaking, the world-building methodologies found in science fiction, and political and historical distinctions between fact and fiction. She was the 2019–20 fellow at the Curatorial & Research Residency Program at the Julia Stoschek Collection in Düsseldorf, Germany, where she curated the exhibition *JSC on View: Mythologists* (2021–22). Her exhibitions have been written about in *Hyperallergic, Artsy, KUBA Paris, Brooklyn Magazine, Art F City*, and more. As an independent curator, she has curated exhibitions locally and internationally and spoken at universities throughout the US. She has an MA from Bard College's Center for Curatorial Studies and a BFA from Pratt Institute in Brooklyn.

ABOUT THE ARTIST

Victoria-Idongesit Udondian received an MFA in Sculpture and New Genres from Columbia University, New York; attended Skowhegan School of Painting and Sculpture and a BA in painting from the University of Uyo, Nigeria. She is currently a Visiting Associate professor of Art at the University at Buffalo, SUNY, Buffalo, New York. Udondian's work is driven by her interest in textiles and the potential for clothing to shape identity, informed by the histories and tacit meanings embedded in everyday materials. She creates work that questions notions of cultural identity and post-colonial positions in relation to her experiences growing up in Nigeria. She examines the intersectionality between immigration, labor, and global trade systems, and raises questions about our post-colonial condition. In 2020, Udondian was named a Guggenheim Fellow in the United States of America. Her works have been exhibited internationally at The British Textile Biennial, United Kingdom; Hacer Nocer at Museo Textil de Oaxaca, (Textile Museum of Oaxaca), Mexico; The Bronx Museum, New York; The Inaugural Nigerian Pavilion at the 56th Venice Biennial-An Excerpt; Fisher Landau Centre for the Arts, New York; National Museum, Lagos; Centre for Contemporary Arts (CCA), Lagos; Spring Break Art Fair, New York; The Children Museum of Manhattan, New York; Whitworth Gallery, Manchester, UK; and the National Gallery of Arts, Uyo, Nigeria. Some of her Artist Residencies include Fountainhead Residency in Miami; Instituto Sacatar, Bahia, Brazil; The Massachusetts Museum of Contemporary Art (MASS MoCA), Massachusetts, USA; Fine Arts Work Centre (FAWC), Provincetown; USA; Villa Straulli, Winterthur, Switzerland; Fondazione di Venezia, Venice, Italy and Bag Factory Studios, Johannesburg, South Africa.

ACKNOWLEDGMENTS

Support for Victoria Udondian's *How Can I Be Nobody* has been provided by a 2020 Guggenheim Foundation Fellowship. It is sponsored, in part, by the Greater New York Arts Development Fund of the New York City Department of Cultural Affairs, administered by the Brooklyn Arts Council. This project was supported, in part, by a Foundation for Contemporary Arts Emergency Grant, and by the University at Buffalo College of Art and Science Research Funds. The artist would like to acknowledge past support from Project for Empty Space (Newark, NJ), South London Gallery (London, UK), and Stitch Buffalo (Buffalo, NY). I would like to thank my amazing collaborators: Mu Mu, Ta Phay, Hnin Si, Muna, and Da John, who all made this work possible. Thanks also to the book's editor, Sylvester Okwunodu Ogbechie, and contributors Rachel Vera Steinberg, Ayanna Dozier, Moyo Okediji, and Akil Kumarasmy.

COLOPHON

Published in 2024 by

Hirmer Publishers
Bayerstrasse 57–59
80335 Munich
Germany
www.hirmerpublishers.com

© 2024 Hirmer Verlag GmbH, Munich, and the authors

Library of Congress Control Number 2023923707
ISBN 978-3-7774-4257-0

Edited by
Sylvester Okwunodu Ogbechie

With contributions by
Ayanna Dozier, Akil Kumarasamy, Moyo Okediji, Rachel Vera Steinberg

Senior editor, Hirmer Publishers
Elisabeth Rochau-Shalem

Project manager, Hirmer Publishers
Rainer Arnold

Copyediting and proofreading
Michael Pilewski, Munich

Design and visual editing
Sabine Frohmader

Prepress
Reproline Mediateam, Unterföhring

Printing & binding
Grafisches Centrum Cuno, Calbe

Paper
GardaMatt Art, 170 g/sqm

Typeface
Halyard, Movement

Printed in Germany

front cover: Detail of *Akaisang ye Beyond Cages; 1277, 1245*, 2019–2022 (pp. 88–89)
back cover: Detail of *Ndise Mmi (self-portrait)*, 2013 (pp. 70–71)
p. 4: Detail of *Oba-hyphenated*, 2017 (p. 63), Image credit: Naya Bricher

IMAGE CREDITS

Argenis Apolinario:
front cover, pp. 88, 89, 90, 91

Jack Bolton:
pp. 80, 81

Naya Bricher:
pp. 4, 25, 63

Etienne Frossard:
pp. 9, 11, 12, 13, 14, 15, 49, 82, 83, 84, 85, 86, 87

Novo Isioro:
pp. 64, 65, 66, 67, 72, 73

Roberto Moro:
pp. 18, 58, 59, 108, 109, 110, 111, 112, 113, 122, 123

Michael Pollard:
pp. 39, 119, 120, 121

Cary Whitter:
p. 118

All images not mentioned above:
Courtesy of the artist